KU-736-784

BETTER PICTURE GUIDE TO

Black & White
photography 2

TERRY HOPE

BETTER PICTURE GUIDE TO

Black & White
photography 2

RotoVision

Property of the College of West Anglia
If found, please return to
The Learning Resource Centre

A RotoVision Book
Published and distributed by RotoVision SA
Rue du Bugnon 7
Ch-1299 Crans-Près-Céligny
Switzerland

RotoVision SA, Sales, Editorial & Production Office
Sheridan House, 112/116A Western Road
Hove, East Sussex BN3 1DD, UK

Tel: +44 (0)1273 72 72 68
Fax: +44 (0)1273 72 72 69
Email: sales@rotovision.com
www.rotovision.com

Copyright © RotoVision SA 2001

All rights reserved. No part of this publication may be reproduced, stored
in a retrieval system or transmitted in any form or by any means,
electronic, mechanical, photocopying, recording or otherwise, without
permission of the copyright holder.

The photographs and diagrams used in this book are copyrighted or
otherwise protected by legislation and cannot be reproduced without the
permission of the holder of the rights.

10 9 8 7 6 5 4 3 2 1

ISBN 2-88046-479-X

Book design by Brenda Dermody, Dublin
Diagrams by Austin Carey, Dublin

Production and separations in Singapore by ProVision Pte. Ltd.
Tel: +65 334 7720
Fax: +65 334 7721

Contents

Composition & Design

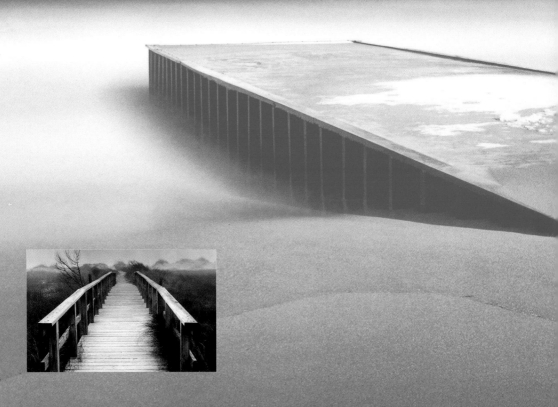

I

Photography is all about seeing an image but it's
the way that you interpret this and then translate
it onto film that will decide whether the picture you take becomes something special or
merely a pedestrian record of an event. Good composition and a mastering of the design
elements of a picture are crucial things to learn. You need to be aware of photography's
ground rules, not so that you can observe them slavishly but so that you can absorb them
and use them when necessary. The great photographer will know
instinctively what looks right in their viewfinder and can then
concentrate instead on capturing the moment. With dedication it is
possible to reach this standard in your own work.

Shapes & Forms

Always look for the natural patterns and shapes that occur in every location and then work to exploit these in your pictures, either through the vantage point that you decide on or through the framing of your picture.

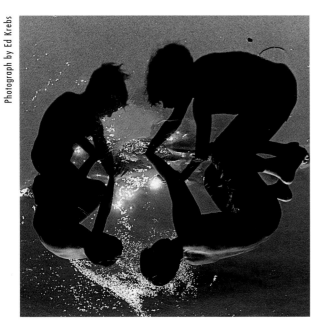

Photograph by Ed Krebs

Ed Krebs saw these two boys playing in the sand as he walked near his home in California, and the shapes of their shadows caught his eye. He made the picture more abstract by printing it upside down and burning in the highlights in the darkroom (see pages 112–113).

Technical Details

35mm compact camera with a Hexanon 28mm lens and Fujifilm Neopan 400 film.

Seeing

The graceful sweep of the bow of this decaying boat on the shore of De Panne in Belgium attracted Pie de Vrede, and he was also taken by the way that the boat had sunk into the sand and was becoming assimilated by its surroundings.

Thinking

The deep shadow created by the late afternoon sun was hiding much of the boat's detail and also skimming the surface of the sand and highlighting its texture, creating strong contrast within the scene.

Acting

By setting his zoom to a short telephoto length and shooting from standing height, Pie could isolate his subject against the background and present a foreshortened perspective. The shadow reduced the scene to its barest elements, while the light catching the top edge of the boat emphasised its still-beautiful shape. A small aperture ensured maximum depth of field and a tripod kept the camera rock steady at the required shutter speed of 1/30sec.

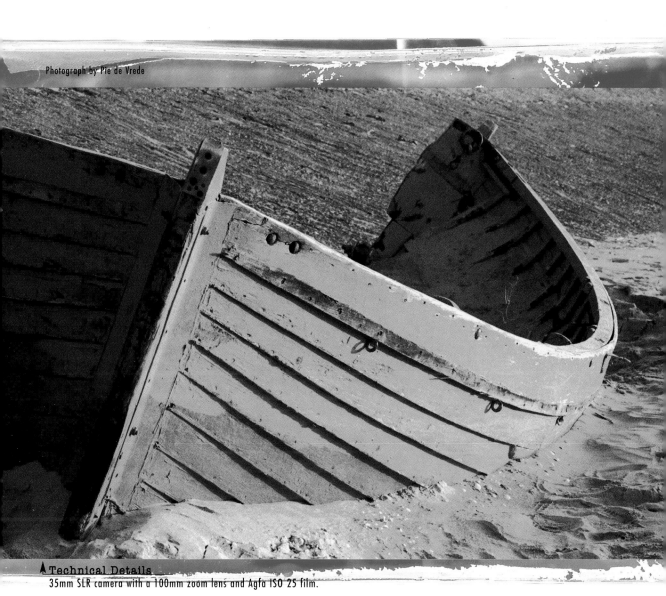

Photograph by Pie de Vrede

▲ Technical Details
35mm SLR camera with a 100mm zoom lens and Agfa ISO 25 film.

Photograph by Chip Forelli

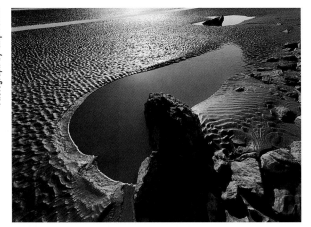

Taken on the South Island of New Zealand, the big challenge that Chip Forelli faced with this picture was finding a selection of rocks that would serve to provide foreground interest. This grouping worked particularly well and Chip moved in close with his slightly wide lens and then set a small aperture so that he maintained depth of field throughout the frame.

Technical Details
6x6cm camera with a 60mm lens and Panatomic-X film.

Rule of Thumb

When shooting a land or seascape it's often a compositional requirement to feature a strong foreground. Look for interesting shapes and textures that can be highlighted and consider fitting a wide-angle lens so that objects closer to the camera will have their relative size exaggerated. A wider lens will also feature greater depth of field, making it easier to keep everything from foreground to horizon in focus.

Seeing
Very simple and dynamic shapes attracted Chip Forelli to this steel pier on Lake Michigan north of Chicago, and he was also struck by the absence of any superfluous detail in the foreground or on the lake itself that would have proved distracting.

Thinking
Faced with the fact that simplicity was the key to the image he wanted to achieve, Chip decided to strip detail away even further by removing the texture that the clouds and sea would have added.

Acting
An extremely slow shutter speed allowed the moving clouds and sea to blur and become smooth tones. The natural light was too intense for the necessary exposure of several minutes so the amount that was reaching the film had to be reduced in some way. Chip chose to fit both an orange filter, which helped to darken down the blue in the sky, and a neutral density filter, which served to cut down the light.

Technical Details
▼ 5x4in camera with a 75mm lens, Kodak Tri-X film and exposure of 6 and a 1/2 min at f/32.

Photograph by Chip Forelli

Using Design

Keep an eye open for natural design that can be utilised in your pictures. The world is full of patterns and shapes that can be exploited through taking up a certain viewpoint or by making use of the perspective offered by a particular lens.

Technical Details
6x6cm camera with a 60mm lens and Kodak T-Max 100 film.

Photograph by Chip Forelli

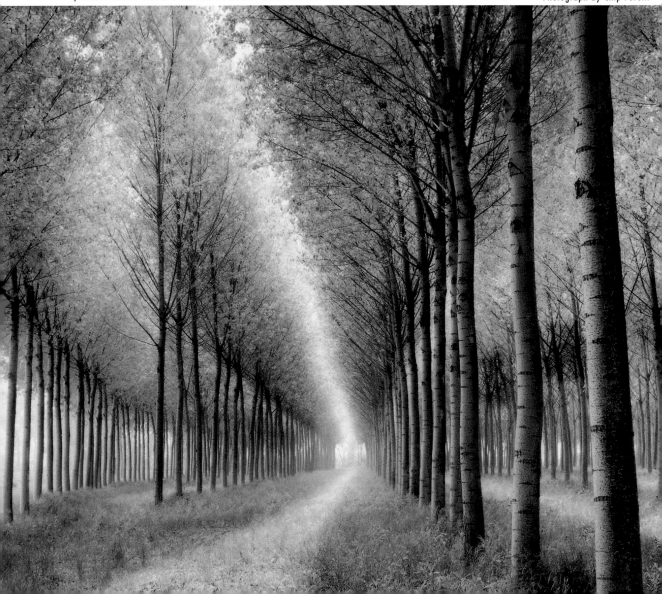

Technical Details
▼ 6x6cm camera with a 100mm lens and Kodak Panatomic-X film.

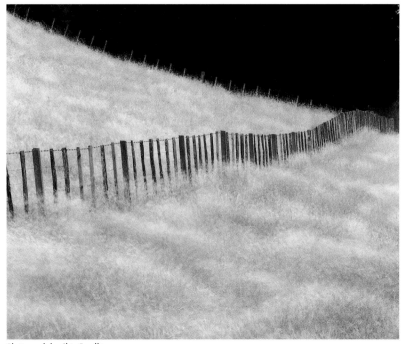

Photograph by Chip Forelli

Chip Forelli came across these impressive lines of trees in the Po River Valley in Italy and, realising the potential of the scene, he looked around for a viewpoint that would make the most of the symmetrical nature of the view. As he wandered close to the edge of the stand of trees, the morning light filtering between them from the left helped to balance the light coming from above and gave him the image he desired.

Seeing
A perfectly ordinary wooden fence and yet Chip Forelli was struck by the pattern it created as it snaked its way across the middle of an open field on the North Island of New Zealand, breaking up an area of light tone that was created by a crop of lush grass. The final element of the scene was an area of shaded trees in the background that made up a contrasting slab of black tone and Chip realised that he had all the ingredients in place for a simple but effective landscape.

Thinking
A stiff wind was blowing and creating movement throughout the scene as the grass swayed and moved and Chip decided that he would set a slow shutter speed and allow the resulting blur to add a surreal touch to the picture.

Acting
Using a slow ISO 50 film and stopping down his lens to f/16, Chip was able to lengthen his shutter speed to half a second. A sturdy tripod ensured that all the stable elements in the picture remained sharp while the movement in the grass was recorded on film.

Leading the Eye

Careful composition can ensure that the viewer is taken through the picture in the way that the photographer intended, with various elements given greater or lesser emphasis according to their placement in the frame.

Photograph by Andy Katzung

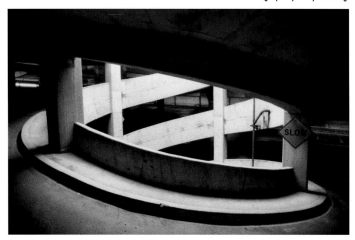

The graceful swirl of this parking ramp in Minneapolis, Minnesota attracted Andy Katzung and he decided to approach closely with a wide-angle lens, allowing the perspective that this offered to emphasise the curves the ramp contained. The soft overhead lighting from a cloudy day further highlighted the shape and brought out the texture of the concrete.

Technical Details
35mm SLR camera with an AF 28mm lens and Ilford HP5+ film.

Seeing
A vantage point on the Pont Neuf bridge in Paris allowed Andy Katzung to look down on a busy riverside road. He was intrigued by the way that the road appeared to be cutting a path through the trees while still remaining in harmony with them.

Thinking
The trees were an essential part of the composition because the geometric line they make through the centre of the picture leads the eye naturally to the top, where the two sections of road converge.

Acting
Having seen the potential of the scene, Andy then had to wait for the lighting to complete the picture. The sun, coming from the top right of the scene, highlighted the left-hand side of the road while shading ensured that the right-hand side was in shadow. This created an interesting contrast, while the two areas of road combining at the top of the frame were in bright sunlight.

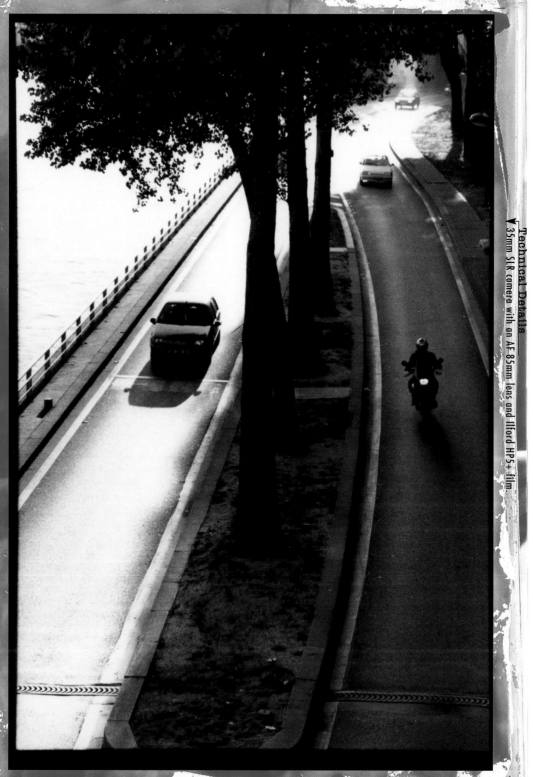

Technical Details
35mm SLR camera with an AF 85mm lens and Ilford HP5+ film

Photograph by Andy Katzung

Rule of Thirds

A useful compositional device when considering how to arrange the elements within the frame is the rule of thirds. Pictures that are too symmetrical will not normally be successful, but those that have been broken up into areas that are equal to one or two-thirds of the picture area will have a more natural and balanced feel.

Technical Details
6x7cm camera with a 90mm lens and Kodak T-Max 100 film.

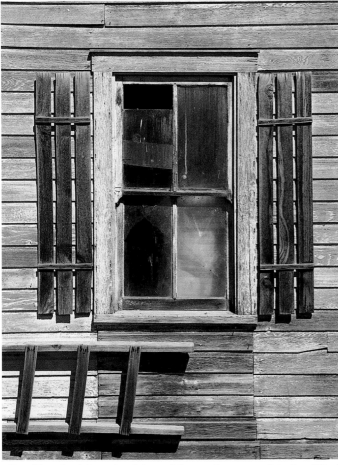

Photograph by Wynn White

Wynn White placed the window of this ranch house in Oregon squarely in the middle of his picture but then composed so that an area roughly the same width as the window was included on either side. The division of the image into thirds, as shown in this illustration, has given it a comfortable and well-arranged feel.

Seeing

This ruined building close to the Dingli Cliffs in Malta caught the eye of Pie de Vrede and he was struck by the strength of its outline against a cloudy sky and the texture of the wall that made up its boundary.

Thinking

A low camera angle served to accentuate the isolation of the building and, taking account of the rule of thirds, Pie framed his picture so that the wall itself became the foreground and the sky was allowed to dominate.

Acting

The use of a long lens presented a typical compressed perspective that allowed the wall to appear closer to the building and closer in scale to it than it actually was, while a red filter transmitted more of the blue part of the spectrum darkening down the sky, emphasising the clouds and making this area of the picture far more dramatic.

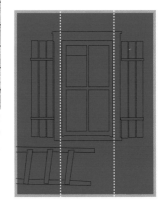

This illustration shows the picture below split into thirds.

Photograph by Pie de Vrede

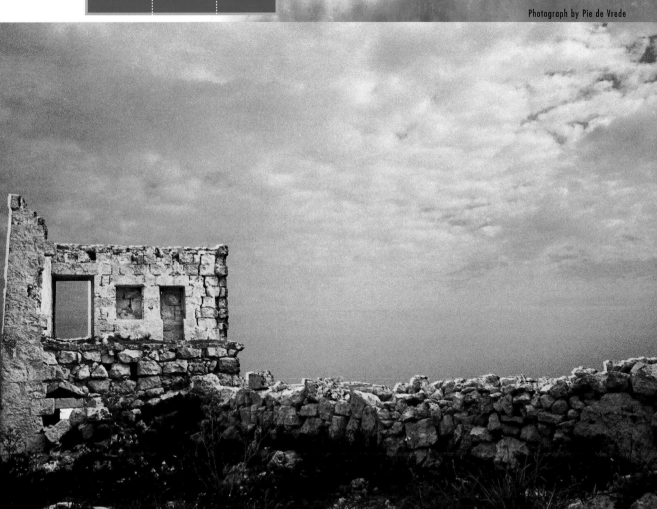

▲ Technical Details
35mm SLR camera with a zoom lens set to 200mm and Agfa APX 100 film.

Tone & Balance

The strength of black and white is revealed through its subtlety, and careful control of exposure and processing will result in a negative that has a full range of tones which can be exploited at the printing stage.

Technical Details

5x4in camera with a 150mm lens and Kodak T-Max 100 film.

Photograph by Naseeb Baroody

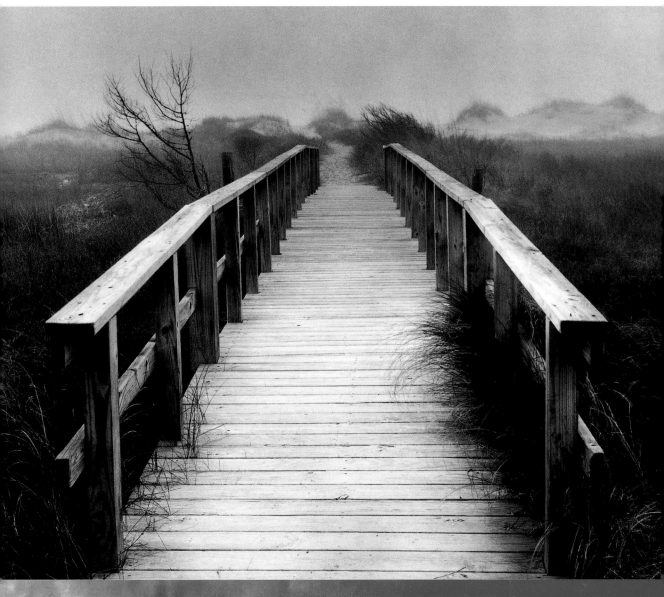

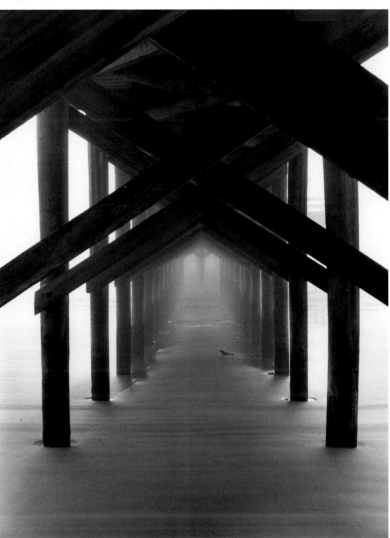

Seeing

This isolated boardwalk in Briarcliffe, South Carolina appealed to Naseeb Baroody because of its **strength** and **simplicity**. The fog in the background helped to heighten the atmosphere and pare down the detail in the picture even further.

Thinking

Naseeb wanted to link the boardwalk with its environment, and make it a visual means of **leading the eye** into the picture while emphasising its solidity and texture.

Acting

By arranging his vantage point so that the boardwalk is firmly in the centre of the picture, Naseeb invites the **viewer** to move along it and into the scene beyond. This is a case where the symmetry of the **composition** has served to strengthen the image and to give it greater purpose.

Naseeb Baroody found the symmetry and design that he was looking for by looking underneath his subject – a pier at North Myrtle Beach in South Carolina. After setting up his camera on a sturdy tripod, he was just about to take his picture when a bird walked into the scene and helped to add a telling final touch.

▲ Technical Details

5x4in camera with a 150mm lens and Kodak Tri-X film.

Contrast & Shadows

The rule book says that strong and contrasty lighting should be avoided at all costs and yet, in practice, it can help to break a black and white picture down into slabs of light and dark tone, something that can add greatly to the drama and the graphic qualities of an image.

Seeing

It was noon and the sun was directly overhead a winding little walkway off the main plaza in San Gimignano in the Tuscany region of Italy. Ron Rosenstock found himself more attracted by the contrast between the areas of highlight and a series of geometrically shaped shadows than he was by the architecture more traditionally photographed by visitors to this ancient and beautiful old town.

Thinking

Because there was no danger of the scene changing rapidly Ron knew that he had time to set up his 5x4in view camera, which allowed him to frame exactly the scene that he wanted while keeping all the horizontal lines in the scene parallel. He also decided that he wanted to emphasise the shadows still further to heighten the contrast that was being naturally created by the sun.

Acting

A 25A red filter was placed over the lens to allow more of the blue light to reach the film and, because shadows are made up of this light, they were selectively darkened down and made to appear stronger than they actually were. To ensure a good depth of field from the front to the back of the picture the lens was stopped down to f/32 and the lack of movement in the scene ensured that a slower shutter speed could be used to compensate.

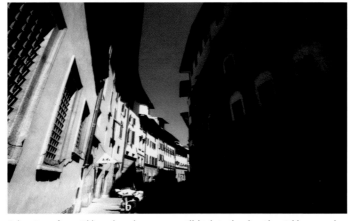

Photograph by Alex Gibbons

Rule of Thumb

Learn to see how natural light is working in a scene and try to mentally remove the colour and see everything as a series of light and dark tones. It's possible with experience to 'read' the way that light is moving and to anticipate when it's likely to give you the effect that you want.

Taken just after midday when the sun was still high in the sky, Alex Gibbons used the harsh contrast of the lighting he encountered in this Milan street to produce a picture that is effectively cut in two through the striking mixture of bright highlight and deep shadow.

▲ Technical Details

35mm SLR camera with a 24mm lens and Kodak T-Max 100 film.

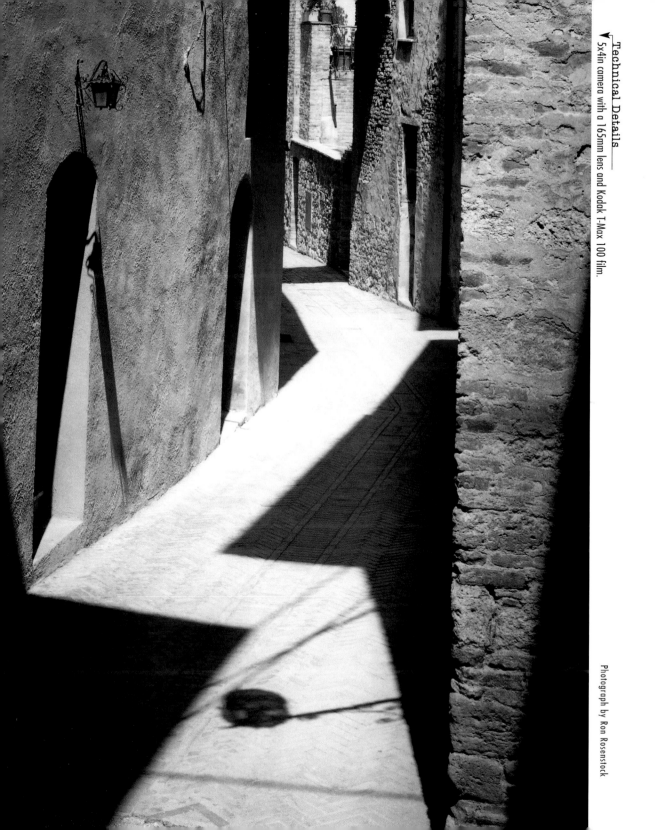

Technical Details

5x4in camera with a 165mm lens and Kodak T-Max 100 film.

Photograph by Ron Rosenstock

Lighting & Mood

The direction of natural light will change continually throughout the day and the mood of a scene will alter accordingly. The astute photographer will learn to assess this delicate relationship between light and shade and can then exploit the subtleties to their advantage.

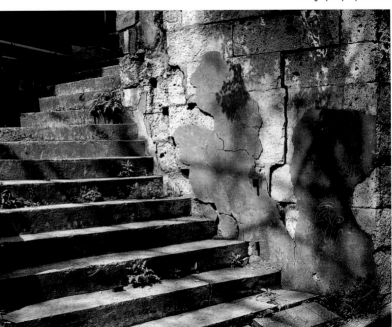

Photograph by Wynn White

Seeing

The shadows playing around these steps in Harajuku, Tokyo, caught the eye of Wynn White and he decided to stop and to see whether the scene contained enough detail to give him a picture.

Thinking

Lighting was coming from a low angle and was just catching the top of the steps, while the shadow being thrown by the branch of a tree was registering on an adjacent wall. Wynn realised that, with the right treatment, these elements could work well together.

Acting

Using a hand-held camera allowed Wynn to adjust his viewpoint quickly and easily. He decided the best approach was to move in close so that his composition was tight and all extraneous detail had been cropped out. This concentrated interest on the form of the steps while allowing enough of the branch's shadow to register to define its outline.

Technical Details ▲
6x7cm camera with an 80mm lens and Kodak T-Max 400 film.

Photograph by Dominic Ciancibelli

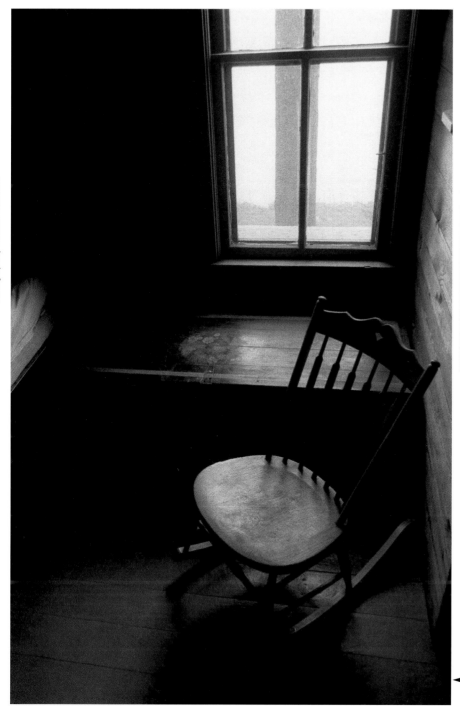

As illustrated above, Dominic Ciancibelli used the subtle light entering through the window of this cottage on the shores of Lake Michigan to pick out just a few details of the ledge and the rocking chair. The mood of the picture is created as much by the areas that are in shadow as it is by the elements that can be seen.

Technical Details
35mm SLR camera with a 55mm lens and Kodak Plus-X film.

Lighting & Mood

Technical Details
▼ Both with a 35mm SLR camera with a 35mm lens and Kodak Tri-X film.

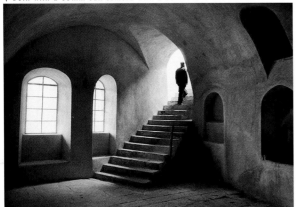

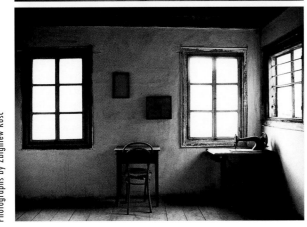

Photographs by Zbigniew Kosc

Photographer Zbigniew Kosc took both these pictures as part of a personal project to document life in the monasteries of the Holy Mountain Athos in Greece. Zbigniew's use of moody natural lighting, created by the contrast between intense sunlight outside and the darkness of the surroundings inside, was a fundamental element of the work.

Seeing

The ancient monasteries around the Holy Mountain Athos in Greece were bathed throughout the day in intense sunlight but featured windows and doors that allowed just a tiny amount of this to enter inside. Zbigniew Kosc was struck by the contrast of brightness and shadow and based a personal project around this feature.

Thinking

A position at the top of a set of stairs allowed both a doorway and a window to be included in this composition, and yet these two areas of brightness could be set against the all-pervading areas of shadow that typified the monasteries in this area.

Acting

Zbigniew took his exposure reading from the section of wall and passageway to his right where a medium range of tones could be found, allowing the intense highlights and shadows elsewhere in this picture to create the mood.

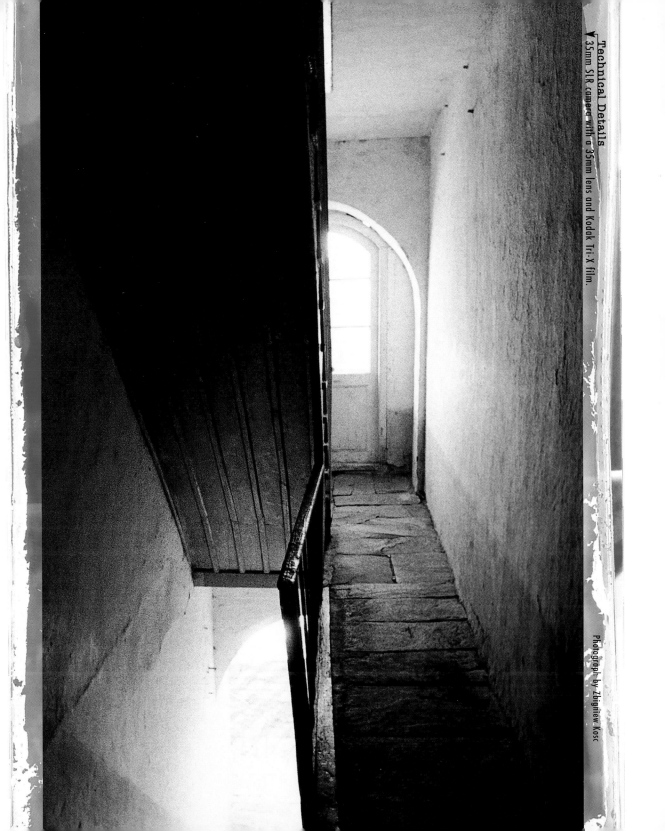

Technical Details — 35mm SLR camera with a 35mm lens and Kodak Tri-X film.

Photograph by Zbigniew Kosc

Texture & Form

Even the most insignificant of objects or the smallest of details can have incredible texture and form that can be unlocked by careful use of light and shade and the right choice of viewpoint.

Photographs by Wynn White

Light hitting a subject from a low angle, usually at the start or finish of a day, is the best for highlighting texture because it will reveal fine detail through the high contrast that is created. Wynn White utilised this type of lighting to make this strong study of a heavily weathered side of an old ranch he came across in Oregon.

▲ Technical Details

6x7cm camera with a 90mm lens and Kodak ISO 25 Technical Pan film.

Fascinated by these worm casts he found encrusted on a rock, Wynn White waited for the natural light to reach a point where it was from a low enough angle to create strong shadow and this then served to emphasise their form and structure.

▲ Technical Details

5x4in camera with a 210mm lens and Kodak T-Max 100 film.

Seeing

Entering the relatively unexplored Waterhole Canyon in Utah, part of the larger Paria Canyon, Libor Jupa was struck by the extraordinary shape and form of the rock, made all the more dramatic by the bands of lighter deposits that made up its structure.

Thinking

Libor wanted to show the location as it was and to allow the natural curves of his subject to lead the viewer's eye into the picture. The shape of the rocks was emphasised by the fairly diffused light filtering in from almost directly overhead, which turned the hollows into deep shadow and helped to define the form of the structures.

Acting

Anxious to avoid creating any distortion in the scene Libor opted to use a lens that was a little longer than the standard 90mm to achieve a perspective that was compressed slightly. He then took up a central position and ensured that his camera was square-on to his subject so that the sides of the rock were not made to appear as though they were converging.

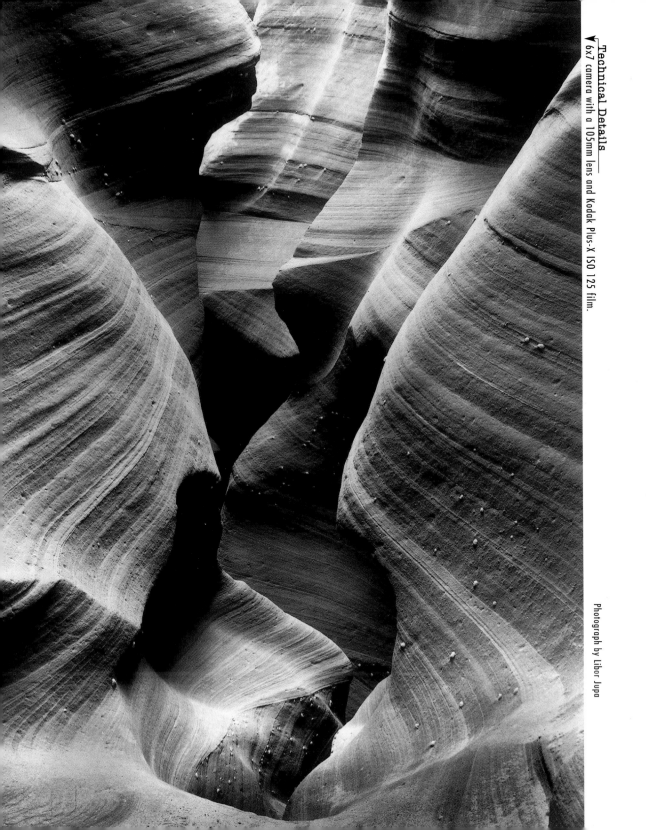

Technical Details
6x7 camera with a 105mm lens and Kodak Plus-X ISO 125 film.

Photograph by Libor Jupa

The world is full of natural shapes and patterns that can be exploited by the photographer. Black and white is a particularly good medium with which to record them because, by taking away the distraction of colour, it will allow the elements in a scene to be reduced to their most basic form.

Seeing

When Wynn White saw the face of this log he realised that it contained wonderful natural patterns and textures. Not only did the characteristic growth rings give him a set of repeated shapes to work from but the action of weathering had also added deep splits that provided a secondary set of complementary shapes.

Thinking

The day was overcast and so the light hitting the subject was flat and diffused. The conditions were ideal for a close-up picture which would accurately record all the tone and detail of the subject.

Acting

Wynn decided to frame tightly so that there was no suggestion of scale included, while the edges of the subject were excluded to avoid the context of the pattern being too immediately recognisable.

Photograph by Wynn White

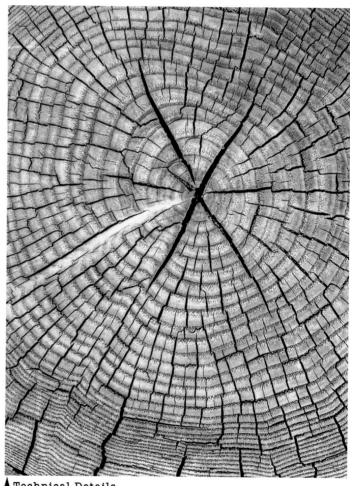

Technical Details
5x4in camera with a 150mm lens and Kodak Tri-X film.

Photographs by Wynn White

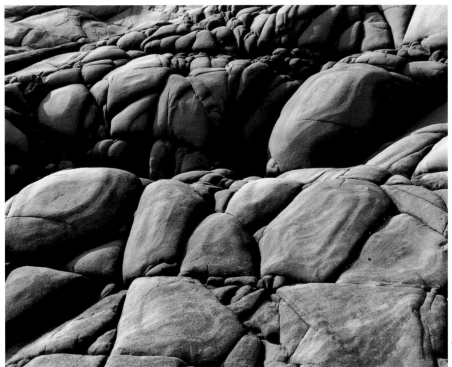

Lighting is everything in terms of how it will affect the subject that you want to photograph. Flat overhead lighting would have robbed these boulders of much of their form and texture, whereas the subtle sidelighting encountered by Wynn White created shadow that helped to define their shape for the camera.

Technical Details
5x4in camera with a 210mm lens and Kodak T-Max 100 film.

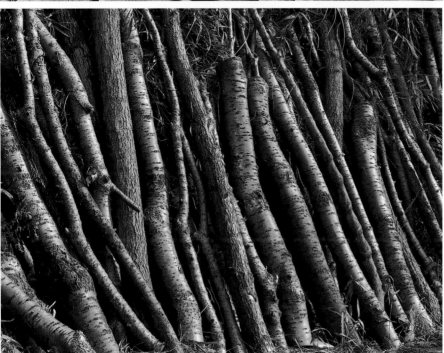

This stack of cut tree trunks appealed to Wynn White because it was full of natural tones and textures. Because the light was hitting the scene from an angle it allowed shadows to creep in between the wood, defining the individual shapes while the bark has been highlighted thanks to its reflective qualities.

Technical Details
5x4in camera with a 150mm lens and Kodak Tri-X film.

Texture in Nature

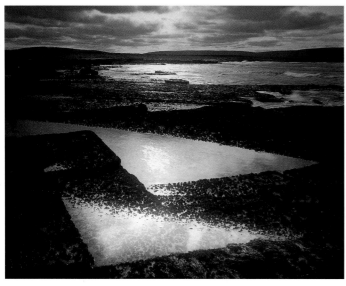

Photograph by Ron Rosenstock

A low sun was throwing light towards the camera and grazing the surface of these barnacle-encrusted rocks by the sea on the North Mayo coast of Ireland. Ron Rosenstock realised he could use the effect to make a picture that revealed the natural texture of the scene. The angle of the light, around 45 degrees, also reflected off the surface of the water in the pools and served to highlight their striking triangular shapes.

⋏ Technical Details
5x4in camera with a 90mm lens and Kodak T-Max 100 film.

Seeing
A low afternoon sun was creating harsh shadows and strong **modelling** around these jagged rocks at Down Patrick Head in County Mayo, Ireland, allowing the textures of the heavily weathered surfaces to be picked out in sharp relief.

Thinking
By facing towards the light Ron Rosenstock **accentuated** the contrast within the scene and picked up on the **reflective** properties of the water contained in pools scattered around the landscape. Careful positioning allowed him to feature the sun in the foreground of his composition as a bright highlight.

Acting
The contrast was heightened still further by the use of a **25A red filter** that allowed more blue light to reach the film, darkening down the water, rock and blue sky while ensuring that the clouds and specular **highlights** of the sun's reflection remained very bright.

Rule of Thumb
Facing the light source is contrary to the rules of photography but can be highly effective on occasions. Extreme care has to be taken, however, to avoid creating flare, and some form of shield, such as a sheet of card held just out of the frame, should be used to ensure that light doesn't directly hit the lens. Ron improvised here by using his hand to create a shadow that covered the lens.

Technical Details
▼ 5x4in camera with a 90mm lens and Kodak T-Max 100 film.

Photograph by Ron Rosenstock

Cropping the Image

Arranging the elements within the frame to create a pleasing composition is one of the most delicate arts of photography and even the slightest change of viewpoint can alter the meaning of a picture completely. The photographer can, however, fine tune composition and change the emphasis of a picture even after the initial taking stage, through the careful use of cropping.

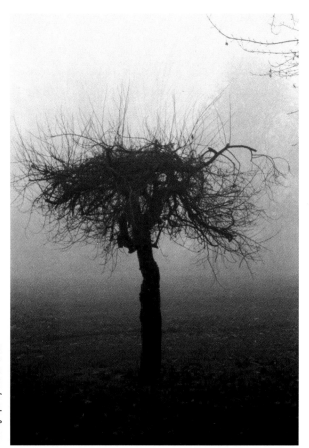

Seeing

The futuristic cityscape of La Defense in Paris – particularly the reflective nature of the surfaces used on many of the buildings there – attracted Pie de Vrede and he decided to make a picture that played on these elements.

Thinking

By tilting his camera upwards and using a wide lens, Pie was able to accentuate the effect of converging verticals, which added greatly to the drama of this scene. To provide a contrast, Pie included a section of building to the right in deep shadow and this was darkened down further at the printing stage to provide a dense block of dark tone.

Acting

The 35mm format precludes an uncropped picture being any shape other than rectangular, which doesn't always suit every scene. Here the amount of dark tone to the right dominates rather too much (see above right), and benefited from being cut back so that the final format of the picture was square.

Technical Tip

When looking to crop an image at the printing stage, first produce a rough print of the complete image. Then take two 'L-shaped' cards, reverse one so that its right-angled corner is diagonally opposite to the other, and then move the two across each other to determine how any other crop would look in reality. It's a very quick way of seeing how strong an image will be if certain elements are excluded or if a new format is used.

The solid form of this mist-shrouded tree spotted by Pie de Vrede in the garden of a castle in Maastricht has been emphasised by its placement firmly in the centre of the frame.

Photograph by Pie de Vrede

Technical Details
35mm SLR camera with a 150mm len and Agfa APX 100 film.

Photograph by Pie de Vrede

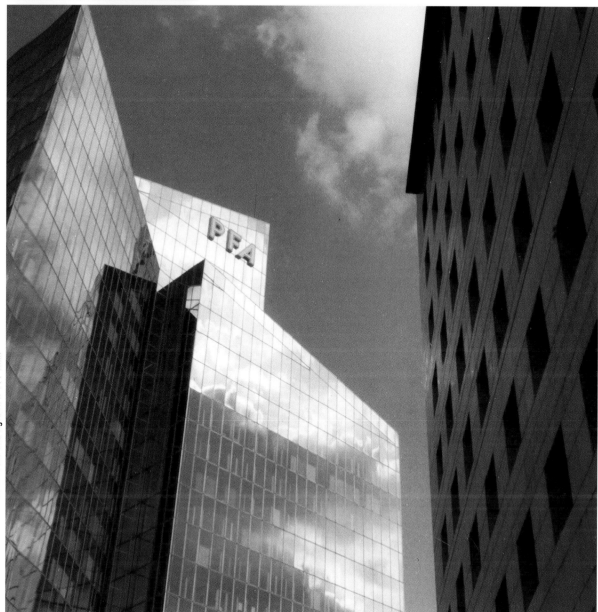

Technical Details
35mm SLR camera with a 35mm lens and Agfa APX 100 film.

Cropping the Image

Photograph by Glyn Edmnunds

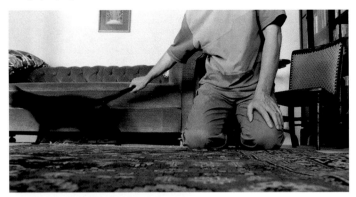

For this shot, the camera was placed low down on a tripod and the self-timer activated, giving Glyn 8 seconds to get himself into the frame for an unusual self-portrait. A narrow crop was most successful, and emphasised the fact that the cat was about to escape from view when the shutter fired. Glyn excluded his face from the picture to add a slightly surreal touch and to focus attention on his feline subject.

▲ Technical Details
35mm SLR camera with a 20–35mm zoom lens and Fujifilm Neopan 1600, downrated to ISO 800.

Seeing
Photographer Glyn Edmunds was taking part with several others in a workshop and had little chance to arrange any one-to-one shooting with a model who was undertaking her first commercial assignment.

Thinking
Glyn realised that he wouldn't achieve any sense of intimacy in his picture unless he moved in close and took steps to cut out some surroundings, allowing attention to be concentrated purely on his subject.

Acting
Very tight in-camera framing emphasised the main area of interest in the picture – the strong and contrasting diagonals created by the model's arms and legs, and subsequent cropping of the 35mm image at the printing stage into a square format, further strengthened the image. It was not necessary for the whole of the model's body to be included in the final picture, as the composition became strengthened by the exclusion of non-essential information.

Technical Details ➤
35mm SLR camera with an 85mm lens and Ilford Delta 100 film.

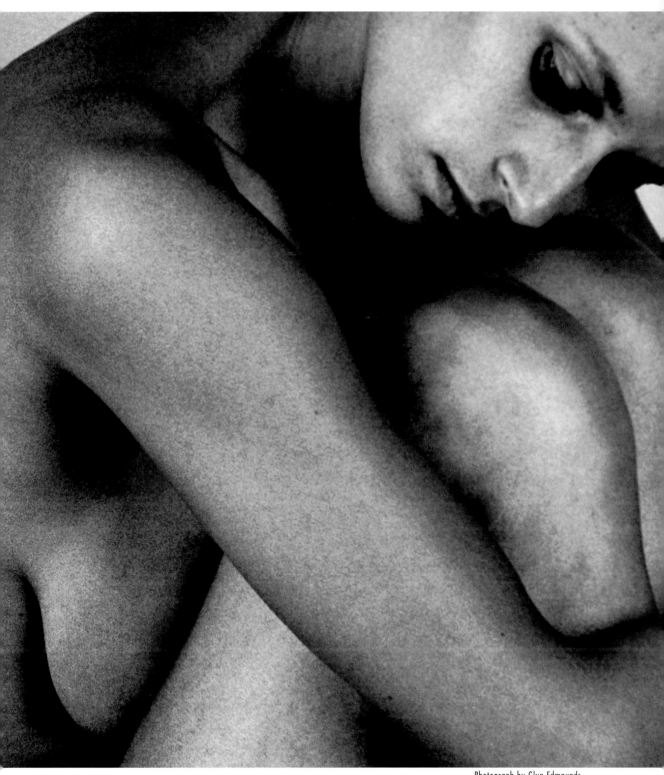

Photograph by Glyn Edmnunds

Framing the Image

The framing of a subject within the viewfinder is vital in determining the ultimate strength of the composition. This is where the balance and feel of the picture is decided and the photographer will need to be aware of how elements complement and interact with each other.

Seeing

David Myers wanted to produce a picture that emphasised the skills of a subject who was a trumpet player, and he was keen to keep the picture **uncluttered** to concentrate attention on the man's relationship with his instrument.

Thinking

A low camera angle emphasised the strength of the subject and a **single light** placed to the left ensured that detail became progressively hidden by shadow towards the right of the picture.

Acting

The subject was framed tightly for maximum effect, the **zoom lens** being used for simple adjustment of the **viewpoint** without the need to move from the taking position. It wasn't necessary for the whole subject or even the complete instrument he was playing to be included to fully convey the theme of the picture.

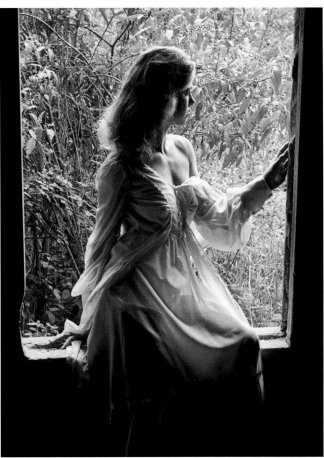

Photograph by Greg Fight

By asking his subject to sit in the window of this abandoned building near Tampa in Florida, Greg Fight created a classic frame around his model, one that has helped to create a natural border on three edges of the picture.

▲ Technical Details

35mm SLR camera with a 35mm lens and Kodak Tri-X film.

Technical Details
▼ 35mm SLR camera with a 80–200mm zoom lens and Agfa APX 100 film.

Photograph by David Myers

Abstractions (Linear)

Linear patterns are to be found everywhere in life and their graphic qualities, especially when the design has been extensively repeated, are particularly suited to a black and white abstract treatment.

Technical Details
▼ 7x17cm technical field camera with a 360mm lens and Ilford FP4 film.

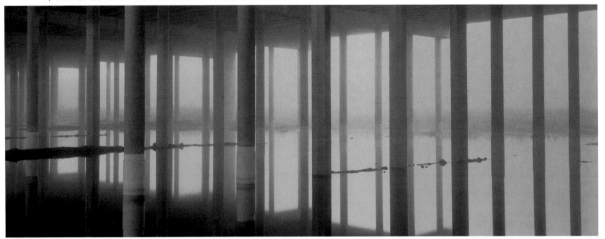

Photograph by Kerik Kouklis

Kerik Kouklis found that the supports for the Yolo Causeway in Sacramento, California, which were reflected in the water, made a wonderful series of strong uprights for his panoramic camera.

Seeing

The Venetian blind located next to this door in Tacoma, Washington caught the eye of Wynn White and he realised that the potential existed for a picture which would exploit the strong lines contained in each of these elements.

Thinking

The blind was partially closed to strengthen its pattern and to hold back some of the light that was coming through the window, and then the door was swung back against this. Because it was glass-fronted it meant that the blind was still visible throughout most of the picture.

Acting

A viewpoint face-on to the subject and at around waist height allowed the strong vertical lines of the door to contrast with the repeated horizontal lines of the blind. Placing the edge of the door off-centre in the frame saved the composition from becoming too symmetrical and obvious.

Technical Details ►
6x7cm camera with a 90mm lens and Kodak T-Max 100 film.

Photograph by Wynn White

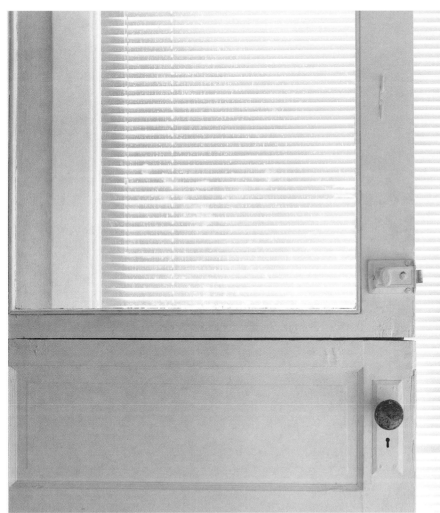

Abstractions (Patterns)

Looking closely at the detail of almost any scene will reveal all kinds of pattern, some natural — some decidedly man-made. Tight framing to remove distractions and an eye for composition to arrange all the vital elements in a visually pleasing way in the viewfinder can result in hugely successful abstract studies.

Seeing

Spotting this spectacularly painted vintage Ford Coupe parked up at a local car show, Dominic Ciancibelli decided to produce an **abstract** image by concentrating on some of the paint details around the vehicle's fender.

Thinking

Dominic framed so that just enough of the car and its **flame motif**, along with a fragment of road, was included to allow it to be identifiable but he excluded the majority of the bodywork so that the image was significantly simplified.

Acting

The use of black and white film excluded all the colour from the scene and **simplified** it even more, allowing the contrast between the straight lines of the running board and the curves of the paintwork to be fully exploited.

Photograph by Dominic Ciancibelli

⋀ Technical Details
35mm SLR camera with a 28–135mm zoom lens and Kodak Plus-X ISO 125 film.

Photograph by Dominic Ciancibelli

▼ Technical Details
35mm SLR camera with a 55mm lens and Kodak Tri-X film.

Above: Peeling paintwork found on the walls of buildings around San Francisco fascinated Dominic Ciancibelli who made it the subject of an entire series of pictures. The random nature of the patterns which he found ensured that no two pictures were ever the same.

Right: Ron Rosenstock set up his field camera around two feet from these Agave plants in Ecuador and concentrated on detail at their centre, which he found most revealing in terms of natural pattern.

Photograph by Ron Rosenstock

Technical Details
5x4in camera with a 135mm lens and Kodak T-Max 100 film.

Seeing Subjects

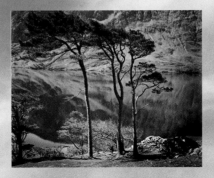

2

The black and white photographer will
need to master the art of reading the
tones rather than the colours within a scene and, once this has
been done, the realisation will follow that there are subjects for
the camera literally at every turn. Using black and
white cuts down on distractions often inherent within
a picture and allows the scene to be simplified and
the main visual points emphasised accordingly.

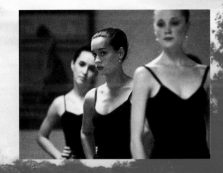

Candid Portraits

Candid portraiture represents one of the greatest challenges to the photographer and yet the rewards are enormous, because the spontaneity it relies upon brings these pictures closer to a truthful representation of your subject than any other approach.

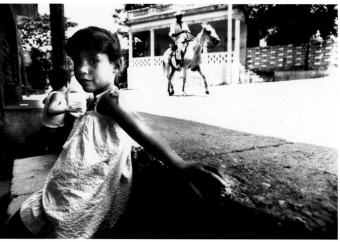

Photograph by Lorenzo DeStefano

Above: Taken during his journey around Cuba, Lorenzo DeStefano used an extreme wide-angle lens to allow him to approach close to his subject, while the perspective of the 24mm lens also ensured that the length of the girl's arm was exaggerated and used to draw the viewer into the picture.

Technical Details
35mm SLR camera with a 24mm lens and Kodak Panatomic 32 film.

Below right: The wide view offered by a 24mm lens allowed Lorenzo DeStefano to shoot from the window of the jeep he was travelling in, capturing the exuberance of this group of young mango pickers.

Technical Details
35mm SLR camera with a 24mm lens and Kodak Panatomic 32 film.

Seeing

Lorenzo DeStefano saw this elderly man standing at the doorway of his house in La Yaya, Cuba, while on a seven-day photographic expedition across that country by jeep. He was attracted by the man's peaceful expression and by the textures revealed in the surface of the decaying wooden structure he lived in.

Thinking

Rather than set up anything too formal, Lorenzo decided to ask the man to remain where he was and to work around him. This approach allowed him to react to the scene and to present his feelings about the man's situation in an honest and straightforward way.

Acting

To integrate the man with his home Lorenzo decided to use a 6x17cm panoramic camera, which allowed a long thin slice of the building to be included in the composition, with just the odd strand of roof included to suggest the size of the structure. Positioning the man directly in the centre of the picture gave it symmetry and drew the eye immediately to this point.

Technical Details

6x17cm camera with a 90mm lens and Agfa APX 100 film.

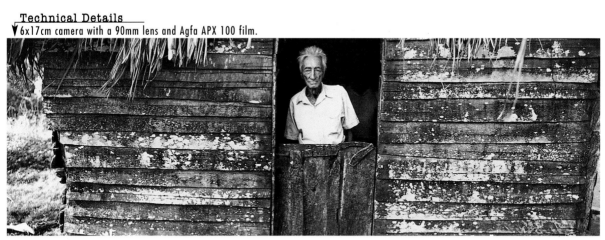

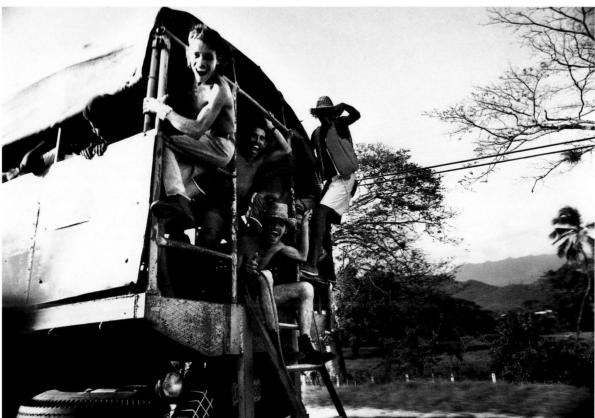

Photographs by Lorenzo DeStefano

Portraits

Formal portraiture is ideally suited to black and white because, such is the tradition of the medium, it can bring a sense of gravitas and quality to the image while also allowing light or colour considerations to become less of an issue.

Photograph by Cristina Piza

Seeing

Photographing a music event in Havana, Cuba, Cristina Piza found that the venue and the lighting was offering her very little and so she decided to concentrate instead on faces in the audience. She approached this subject because she found the shape of his face and the texture of his skin very appealing.

Thinking

Cristina decided to isolate her subject from his surroundings and so she placed him in front of a plain background and moved as close as she could get with her standard lens so that his face filled the frame.

Acting

By setting the camera to automatic and relying on the latitude of black and white film, Cristina was able to concentrate on her subject rather than becoming distracted by technical considerations. She asked for an unforced expression which achieved a portrait containing a lot of information about her subject's personality.

This portrait was set up by Cristina Piza as part of a project in Havana, Cuba. Rather than try to snatch the picture unobserved she asked permission to take her subject's picture and quickly took a series of three to ensure success.

▲ Technical Details

35mm SLR camera with a 50mm lens and Kodak Tri-X film.

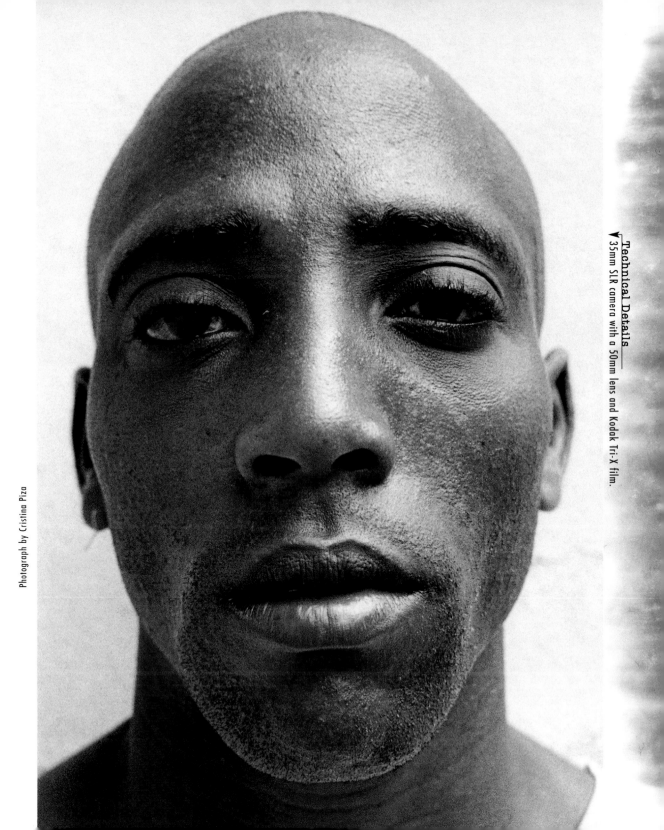

Photograph by Cristina Piza

Technical Details
35mm SLR camera with a 50mm lens and Kodak Tri-X film.

Posing Subjects

When portraiture is being set up with the subject aware of the photographer's presence a certain amount of direction is often called for. It's the photographer's role to add a light touch that will provide the look that's required without making the picture look contrived.

Technical Details
35mm SLR camera with a 300mm lens and Kodak Tri-X film.

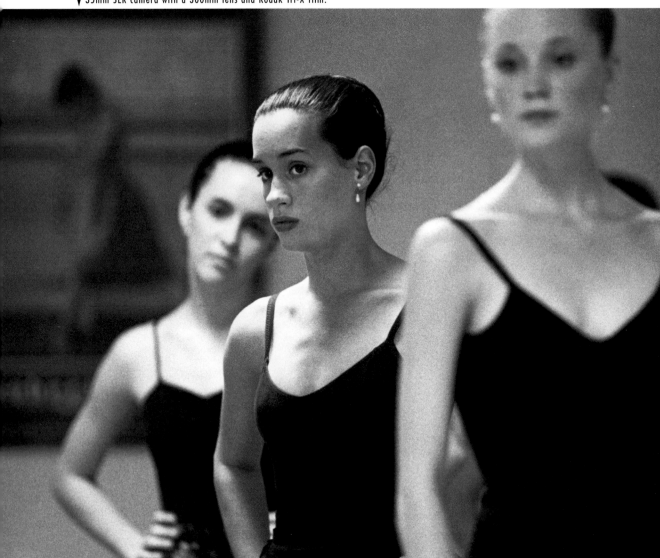

Photograph by Greg Fight

Seeing

Greg Fight saw this line of dancers taking a class at the Florida Dance Theatre and he wanted to make a picture that had a natural feel, but which conveyed some of the tedium behind the scenes in the rehearsal studio.

Thinking

Although the dancers were aware of his presence, Greg asked them to go through their routine as they would normally and he then retired some distance away and filled his frame by fitting a lengthy 300mm lens, which he kept steady through the use of a monopod.

Acting

The narrow depth of field and compressed perspective that the 300mm offered him brought the dancers closer together and ensured that only the central one of the three was in sharp focus. Greg exerted just a light touch by asking his main subject to take care to avoid eye contact with the camera.

Rule of Thumb

Hands are one of the most difficult things to place in a portrait and they can look awkward and ungainly if you don't direct a little from behind the camera. Try to get your subject to relax and see what they do with their hands naturally and, if you feel that you're not getting the look that you want, try to come up with something for them to do.

Photograph by Greg Fight

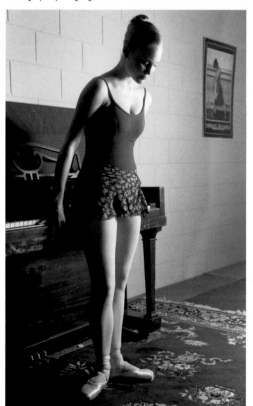

Technical Details
35mm SLR camera with a 35–70mm zoom lens and Kodak T-Max 100 film.

Seeing a piano in the studio, Greg realised it would make an evocative prop and asked one of the dancers to stand next to it and base her pose around it. The piano made a natural rest for the dancer and Greg asked her to place her hands on the keyboard behind her, creating a diagonal with her arm. He also asked her to turn her feet out to add an authentic touch and create a more graceful shape.

Nude Subjects

The nude has been one of photography's most enduring
subjects virtually since the medium was invented and it's
ideally suited to a black and white treatment, particularly if you're looking to
produce an image full of mood and atmosphere.

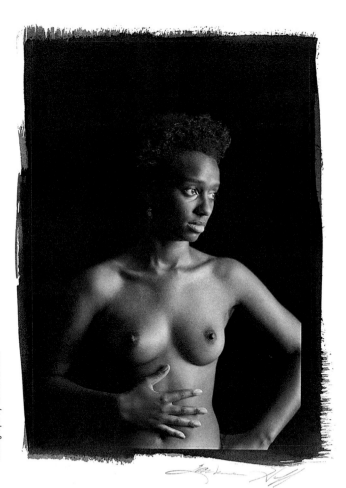

Photograph by Lawrence Huff

Seeing

Working on a personal project to photograph nudes in
abandoned buildings, Lawrence Huff
decided on this occasion to use the **shadows**
within the environment to pare down the picture to
its bare essentials.

Thinking

Lawrence positioned his subject close to a window so
that she was illuminated by strong sidelighting, and
this produced the **modelling** required to add
depth to her body.

Acting

Because his subject was positioned against an area of
dense shadow, there was a distinct
contrast between the lighter tones of the girl's body
and the impenetrable darkness behind her. By asking
his model to look towards the window Lawrence
also ensured that the light picked out the features of
her face. Had she looked directly towards the
camera, the shadows in this area would have been
unflattering and the picture would have lost much of
its **impact**.

Technical Details
5x7in view camera with a 300mm lens and Kodak
Tri-X film.

Photograph by Lawrence Huff

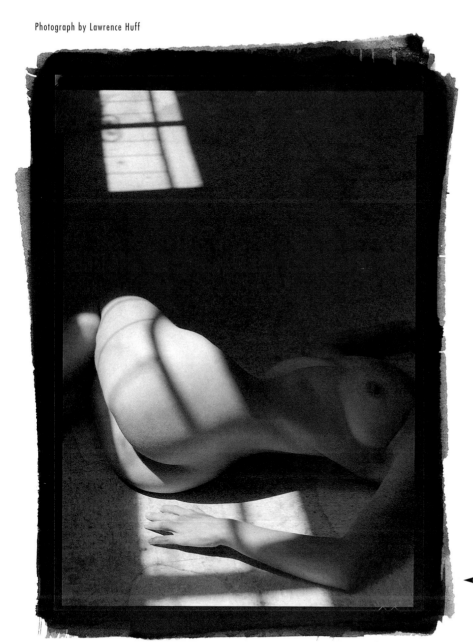

light from window

light from skylight

Black and white materials are
particularly good at simplifying
a scene and reducing it to its most
basic elements. Here Lawrence Huff
has used the contrast between
natural light streaming through
windows and the shadows that have
formed in between to make a very
unusual study of the nude.

◄ Technical Details
5x7in view camera with a 300mm
lens and Kodak Tri-X film.

Still Life (Plants)

The intricate shapes and textures of flowers make them ideal subjects for still life studies and black and white film will allow you to remove the colour and to concentrate attention instead on the form of the subject.

Technical Details
▼ 5x4in view camera with a 135mm lens and Kodak Tri-X film.

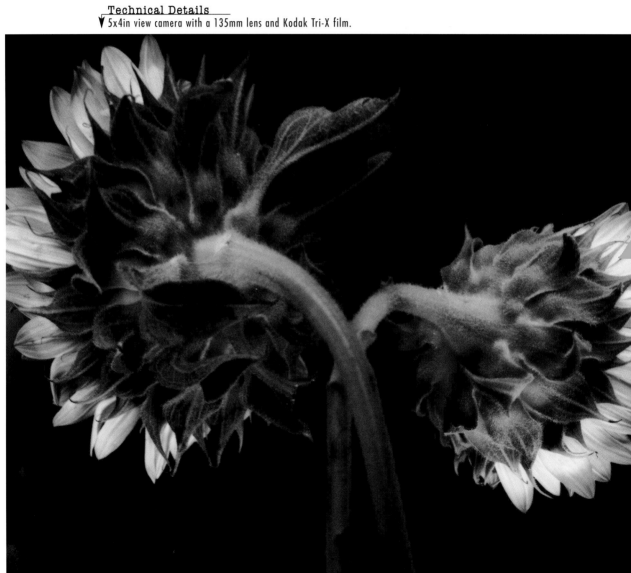

Photograph by Darin Boville

Photograph by Darin Boville

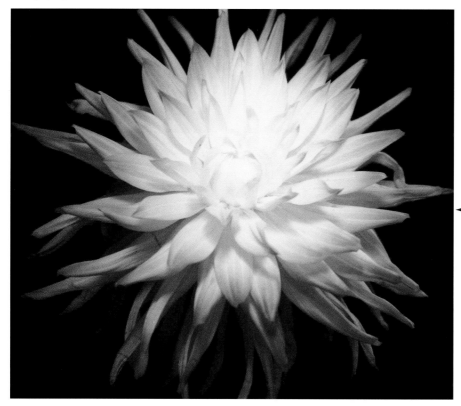

By fitting a lens that was slightly wider than standard, Darin Boville filled his frame with this flower head and then 'painted-in' the light by filling in the detail with a household torch during a lengthy exposure.

Technical Details
5x4in view camera with a 135mm lens and Kodak Tri-X film.

Seeing

Darin Boville wanted to produce an unusual view of sunflowers and so he arranged this pair so they were turned away from the camera, allowing their texture to make the picture.

Thinking

Although he had no access to straightforward studio lighting, Darin wanted to highlight the detail on the flowers and to control how this was picked out against a dark background.

Acting

With the room darkened and the lens aperture set to around f/22, Darin opened his shutter and then started to 'paint- in' the detail on his subject with a small household torch. Working first with a Polaroid print he was able to see where the light had to fall and how much exposure was necessary and he used this as a guide for his final picture.

Close-up & Macro Lens

Moving in ultra close to a subject opens up all
kinds of possibilities for the photographer as
the camera reveals details that are normally too small for the
eye to register.

Photograph by Alex Gibbons

▲ Technical Details
35mm SLR camera with a 45mm lens used in conjunction with a bellows unit and Kodak T-Max 100 film.

Photograph by Ron Rosenstock

Rule of Thumb

There are many ways to achieve a close-up image and bellows extension is just one of them. One option is the macro lens, a specialist optic that gives the photographer the ability to close-focus without using any accessories. These can be expensive but will offer good quality results and ease of use.

Seeing

Realising that insects could provide dramatic subject matter if close-up techniques were employed, Alex Gibbons set himself a project to photograph bees in the Long Wood Gardens, Pennsylvania.

Thinking

Rather than just feature the bee in isolation, Alex decided to photograph the insect in its environment and to include some of its surroundings to put it into context. The extremely narrow depth of field experienced when shooting extreme close-ups guaranteed that the insect could be emphasised within the frame, since it would be the only part of the picture to be fully in focus.

Acting

Alex fitted a bellows unit in between his lens and the camera body, increasing the distance of the front element from the film plane allowing much closer focusing. Because the light had further to travel there was a corresponding increase in exposure time, but a fully automatic bellows unit should still allow the camera's meter to function and so no difficult calculations would normally be required.

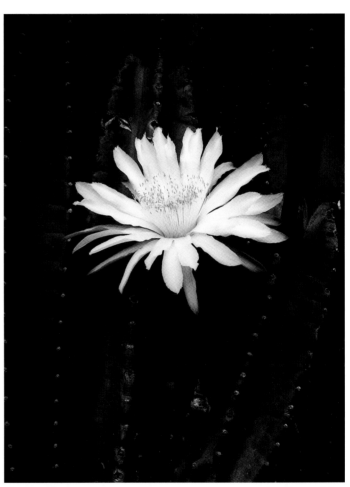

This cactus flower in Kenya was only 4in across so Ron Rosenstock made use of the bellows extension on his large format camera in order to focus closely on his subject. He also had to set an aperture of f/45 to ensure he had sufficient depth of field for his subject to be in overall focus. At the length of bellows extension needed, the light reaching the film plane was diminished and Ron had to calculate reciprocity failure factors to come up with his correct exposure of 5min.

Technical Details
5x4in view camera with a 90mm lens and Kodak T-Max 100 film.

Creative Still Life

A little imagination can allow the photographer to set up a whole series of pleasing still-life studies, which can be arranged to bring the best out of a set of complementary elements while ensuring that they don't have a contrived appearance.

Photographs by Lawrence Huff

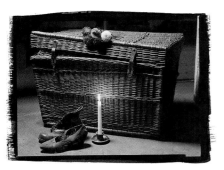 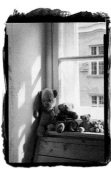

Above left: The theme for this still life was based around articles rescued from the attic and Lawrence Huff made the central feature a large wickerwork basket lit strongly from the side to bring out the texture. The light from the candle created a hotspot in the centre of the picture that draws the eye to this point.

Technical Details
5x7in view camera with a 300mm lens and Kodak Tri-X film.

Above right: This is another gentle still life set up by Lawrence Huff, who took care to shoot at the time of day when a shaft of daylight would feature against the wall to add interest there. Lining the cuddly toys up in height order created a natural flow through the centre of the picture.

Technical Details
5x7in view camera with a 300mm lens and Kodak Tri-X film.

Seeing

Lawrence Huff wanted to produce a loosely arranged still life that would contain many different things, the link being that they were all gifts that had been given to him by a close friend.

Thinking

A cloth was placed over the surface of the table and the background to a point just above the tulips in the centre of the arrangement. This ensured there was nothing to distract from the objects, while enough of the surroundings were visible to indicate that the shot had been set up in an ordinary living room rather than a dedicated studio.

Acting

Care was taken with the arrangement of the objects so that they had a relationship with one another, the thrust of the picture being a deeply personal statement by the photographer. To complete the natural feel, the room's ambient light was used for illumination.

Technical Details
5x7in view camera with a 300mm lens and Kodak Tri-X film.

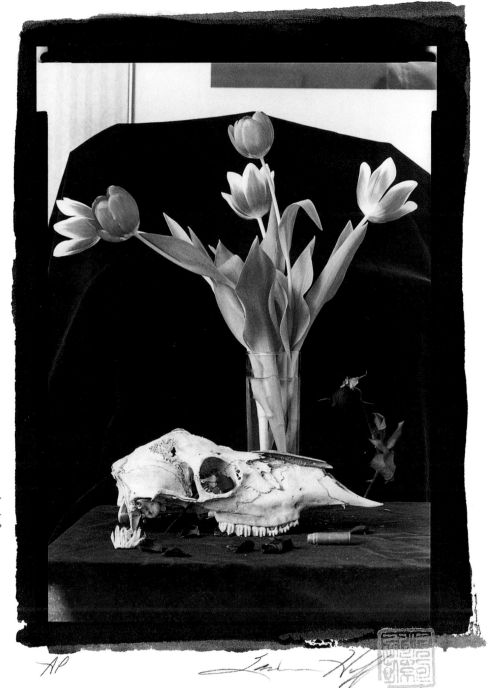

Photograph by Lawrence Huff

AP

Simple Still Life

Don't make things more complicated than you have to. Still life can be highly effective even when the object that's featured is something everyday and mundane but which has been arranged and lit in a particularly stylish way.

Seeing

Lighting a bottle to reveal its form is one of the most **fundamental exercises** that a still life photographer can undertake. Youry Vinetsky decided to take things a stage further by positioning two bottles together which, although identical in height, would contrast with one another through their width.

Thinking

A neutral background was chosen to set off the bottles and the picture was **composed** so that only the top two-thirds of the subjects were included in the frame.

Acting

To bring out a sheen in the surface of the bottles and to emphasise the **roundness** of their shapes, the bottles were lit from the side so that a highlight was created down one edge. As the light fell away, the shadow which formed on the glass helped to define its curve and completed the modelling.

Technical Details ➤
6x7cm camera with a 135mm lens and Kodak T-Max 400 CN film.

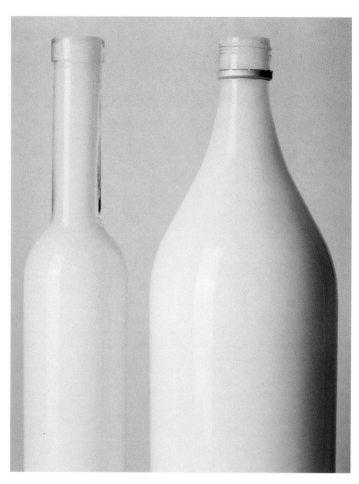

Photograph by Youry Vinetsky

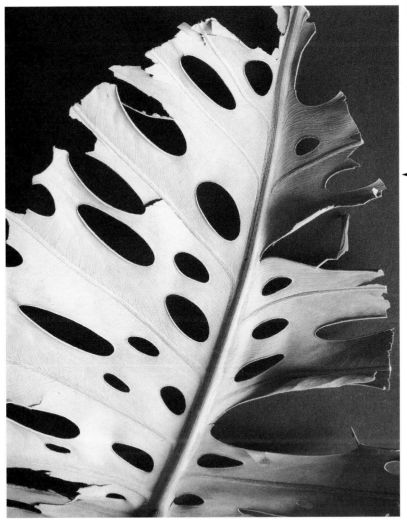

Youry Vinetsky realised that the weathered appearance of this leaf would make it a perfect subject for a simple still life. He used just the one light, which was positioned to reflect back from the surface of the leaf, creating interesting shadows where the surface was less than flat. Because none of this illumination was allowed to reach the background this remained in deep shadow, acting as a foil to the much lighter tones of the main subject.

◄ **Technical Details**

6x7cm camera with a 135mm lens and Kodak T-Max 400 CN film.

Photograph by Youry Vinetsky

Landscapes

The ability of black and white film to reduce a colour scene down to its tonal elements makes it ideal for tackling landscape, allowing both the form and texture of the land to be far more readily expressed.

Technical Details
▼ 6x7cm camera with a 55mm lens and Kodak Plus-X film.

Photograph by Libor Jupa

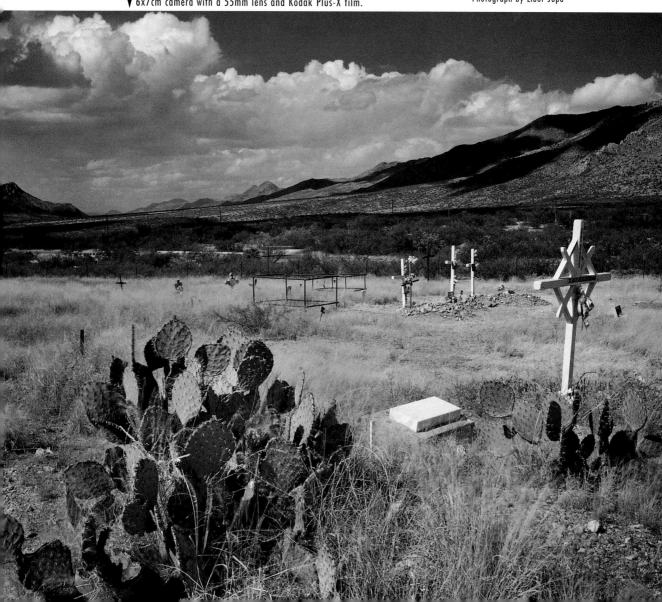

Seeing

As a photographer Libor Jupa has always found himself **visually** attracted to cemeteries and he happened across this one while in New Mexico.

Thinking

The splendid **isolation** of the site was what most appealed to Libor and he decided to make this the **central theme** of his picture, including the range of hills in the background to allow the picture to become a landscape.

Acting

Fitting a wide lens to his camera, Libor took up position close to a cactus plant. The perspective offered by the lens allowed the cactus to be more **prominent** in the frame and provide an interesting **foreground** to the whole image.

Technical Tip

A wide-angle lens will help to keep foreground close to the camera in focus, because one of its characteristics is good depth of field. Focus to infinity and then note where the nearest point of acceptably sharp focus falls. If you then re-focus the lens to that point you will have the greatest depth of field at that aperture that that lens can achieve.

Photograph by Libor Jupa

Technical Details

▼ 35mm SLR camera with a 20mm lens and Ilford HP5+ film.

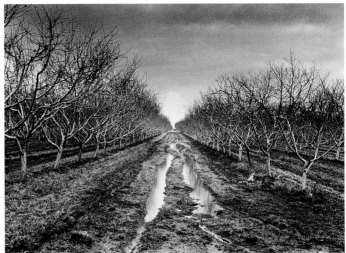

Libor Jupa used an extreme wide-angle lens to make a feature of this rain-sodden path through an orchard. The perspective of this lens emphasised the path while also exaggerating the scale of the trees closest to the camera. This in turn helped to make the line of trees disappearing into the distance more dramatic, a fact that the photographer built on by positioning their meeting point virtually in the dead centre of the frame.

Cropping Landscapes

Faced with a vast landscape it can be daunting to try to convey the entire outlook within one frame. Sometimes it is best to step back and take a different approach, concentrating on just one aspect of the scene, using it to convey something of the atmosphere and spirit of the place that you're photographing.

Photograph by Ron Rosenstock

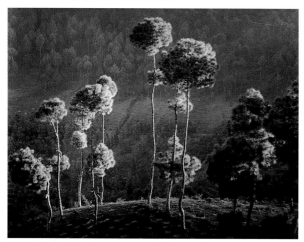

↑ Technical Details

5x4in camera with a 240mm lens and Kodak T-Max 100 film.

Seeing

When he saw a forest of these extraordinary cotton wool trees growing in Visankhukot, Nepal, Ron Rosenstock knew he had to produce a picture which conveyed something of the unusual nature of the scene and his reaction to the place.

Thinking

Photographing a section of the forest would have given little impression of the shape and form of the individual trees and, in many ways, it would simply have resembled any forest landscape.

Acting

Using a long lens, Ron positioned himself so he could isolate a small clump of trees while including a section of the forest in the background. By shooting when the first rays of the sun were picking out the trees in the foreground with those in the background still in shadow, he managed to differentiate the two elements of the picture still further.

The clarity of the reflection on the surface of Doo Lough in County Mayo attracted Ron Rosenstock, and he spent time thinking how he might crop out a section of the scene to convey the spirit of the landscape he had encountered. Eventually, to create a sense of depth in the image, he left out the sky and composed his picture so that a section of darker trees in the foreground were framed against the mountain and the lake. The illustration to the left shows how cropping has improved the picture.

Technical Details
5x4in camera with a 90mm lens and Kodak T-Max film.

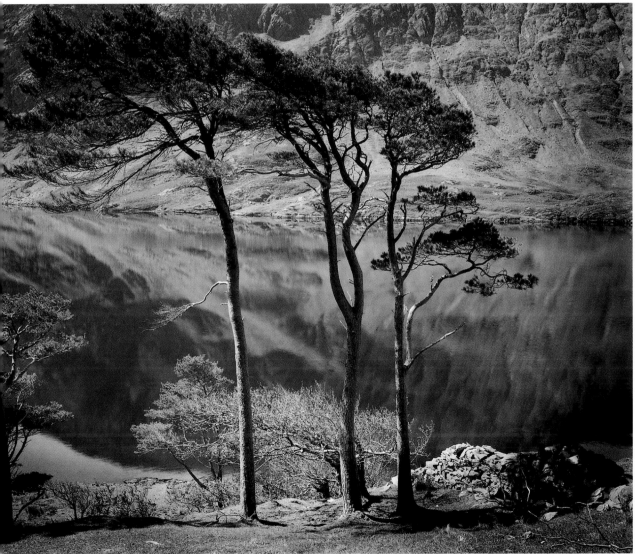

Photograph by Ron Rosenstock

Skyscapes

The sky is a constantly changing element of any landscape and its appearance can make or break a picture. Clouds are the photographer's best ally and their shape and form can add interest to a bland sky and even turn this area of the picture into the main focal point of the composition.

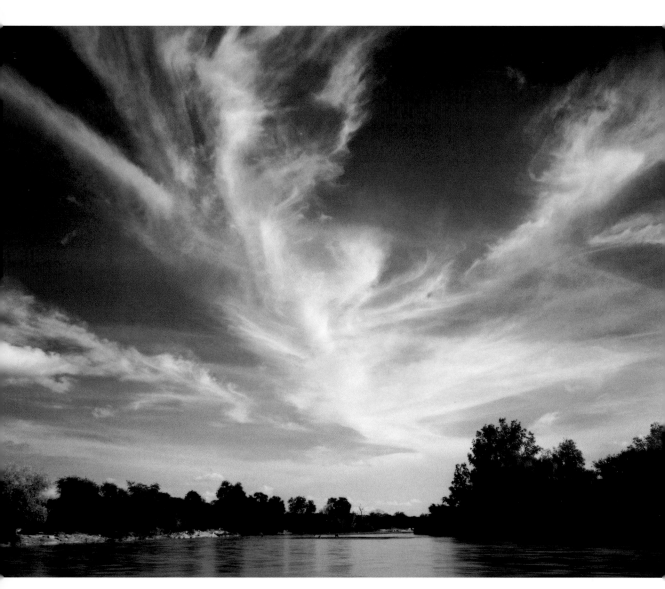

Photograph by Ron Rosenstock

Seeing

While photographing the Athi River in Kenya, Ron Rosenstock realised that the fine sky could become the central point of the photograph that he wanted to produce.

Thinking

Fitting a wide lens, Ron decided to compose his picture so that the river itself only took up a fraction of the frame and became a foil to the shapes and the tone of the dramatic sky.

Acting

To emphasise the clouds still further Ron fitted a 25A red filter to darken down the blue in the sky as well as the green in the trees. Because the filter doesn't affect the colour of the clouds themselves, they retained their pure white appearance and were contrasted against the darker tones.

Lorenzo DeStefano took the unusual step of tilting his panoramic camera to a dramatic angle to take this image of a kite flyer in Cuba. This enabled him to take attention away from a flat and rather uninteresting terrain and to make a central feature of the particularly beautiful clouds he encountered that day.

◄ Technical Details
5x4in camera with a 90mm lens and Kodak T-Max 100 film.

Technical Details ►
Panoramic camera with a 90mm lens and Agfa APX 25 film.

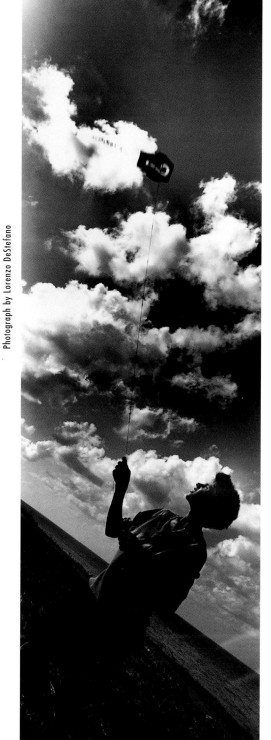

Photograph by Lorenzo DeStefano

Seascapes

The sea is an endlessly inspiring environment, one that offers the potential for a huge range of pictures, from thoughtful detail studies through to dramatic scenes that draw on the enormous power and strength of the ocean in full flow.

Photographs by Naseeb Baroody

Technical Details
▼ Rangefinder camera with an 80mm lens and Kodak T-Max 100 film.

An eye for detail can extract the most extraordinary of pictures from even an everyday situation. Naseeb Baroody spotted the potential created by the particles of foam clinging to this shell at the water's edge and he moved in close and took up a position directly overhead to emphasise the patterns being created.

Technical Details
▼ Rangefinder camera with a 50mm lens and Kodak Plus X film.

Walking down the beach at DeBordieu in South Carolina, Naseeb was struck by the dramatic backlighting he encountered, which turned the surface of the sea into a sheet of silver. The effect was further emphasised in the darkroom by burning in the grass in the foreground (see pages 112–113) to darken it down and act as a foil to the high contrast behind.

Seeing
On an expanse of otherwise featureless beach Naseeb Baroody found this decaying and sun-bleached tree stump that had been washed into position and temporarily revealed by the low tide.

Thinking
The juxtaposition of a tree, the symbol of land, and the sea behind struck Naseeb as an interesting composition and he particularly liked the way the overhead sun was creating intense and short shadows.

Acting
Moving in close to his subject Naseeb made it the central point of his picture, taking up position at an angle that would emphasise the intricacies of its shape. Beyond, the black and white film has recorded the stretch of sand as a simple slab of tone leading the eye to the shoreline, where a wave is breaking just above the tip of a broken root.

<u>Technical Details</u>
▾645 camera with a 60mm lens and Kodak T-Max 100 film.

Photograph by Naseeb Baroody

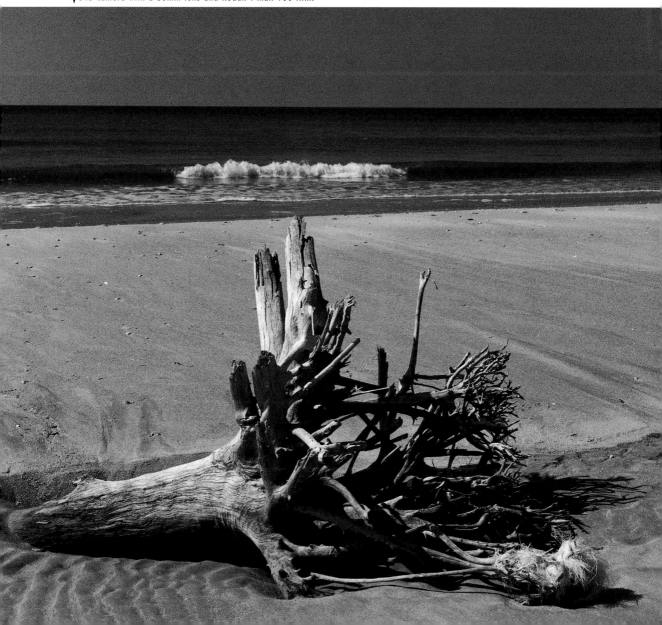

Waterways

Water in its many forms is well worth exploring pictorially and even the dullest urban stretch of river or canal can throw back extraordinary reflections, which can be used to lift a scene and transform it into something beautiful and intriguing.

Technical Details
▼ 645 camera with a 150mm lens and Agfa 400 film.

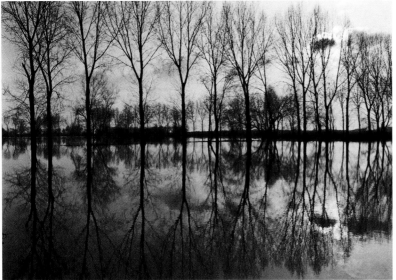

Photograph by Gerard Rhinn

Spotting these trees growing in a uniform line and reflecting in the waters of a lake in Lorraine in the east of France, Gerard Rhinn decided to emphasise the symmetry of the scene and composed his picture so that the horizon fell in the centre of the frame.

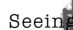

Seeing

An ordinary stretch of riverside in Hamburg, Germany, appeared at first sight to offer nothing special to the photographer, but Gerard Rhinn noticed that the dark surface of the water was reflecting the surroundings in a startlingly clear way.

Thinking

As the wind hit the surface of the water it broke up the reflections and created abstract and wild patterns within the reflection, twisting straight lines, exaggerating curves and also distorting perspective.

Acting

By framing tightly so that the reflections filled the frame and then flipping the picture so that it was effectively upside down – although it appeared to be the right way up – Gerard created an abstract picture which confuses the eye and poses interesting questions.

Photograph by Gerard Rhinn

Technical Details
6x6cm camera with a 180mm lens and Kodak T-Max 100 film.

Architecture

Buildings contain plenty to fascinate the photographer. Look for details, shapes and textures that can be explored visually and take care to relate the architecture to its surroundings and the people associated with it.

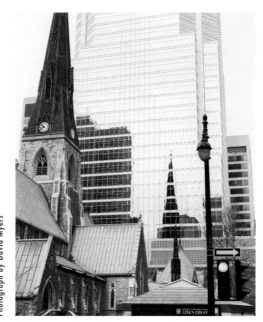

Photograph by David Myers

Looking up at the architecture surrounding him in Montreal, Canada, David Myers was struck by the juxtaposition of new and old and decided to make use of the reflections provided by the coated glass of the modern skyscraper. Tilting his camera up slightly excluded the clutter of the road and allowed the buildings to dominate the composition.

Technical Details
Rangefinder camera with a 50mm lens and Kodak T-Max 100 film.

Seeing

Visiting a Souk in Cairo, Naseeb Baroody decided that he wanted to make a record of the fine architecture he found there, but he also wanted to include the people who were such a vital part of the atmosphere surrounding the place.

Thinking

Discovering a beautiful archway which marked the entrance to one of the shops, he received permission to shoot from inside and to use this architectural detail to frame a group of people in the doorway. He added extra flavour in the foreground by picking out some of the artefacts that were being sold.

Acting

The exposure was taken from inside the building so that the intricate detail of the stonework inside the roof was recorded, while the daylit road outside was allowed to overexpose slightly, its higher contrast acting as a foil to the darker tones of the interior.

Rule of Thumb

Try to link the architecture you're photographing to its environment, so that it is placed in the scene and the viewer has some reference regarding its surroundings. Modern buildings with their highly reflective appearance are a gift to photographers because careful choice of camera position will allow other elements to be included within the composition.

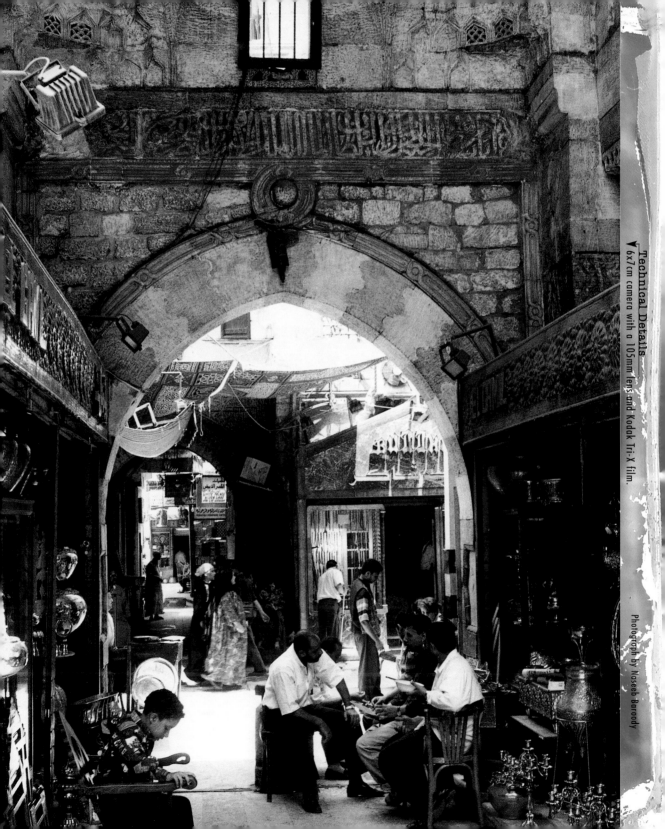

Technical Details
▼ 6x7cm camera with a 105mm lens and Kodak Tri-X film.

Photograph by Naseeb Baroody

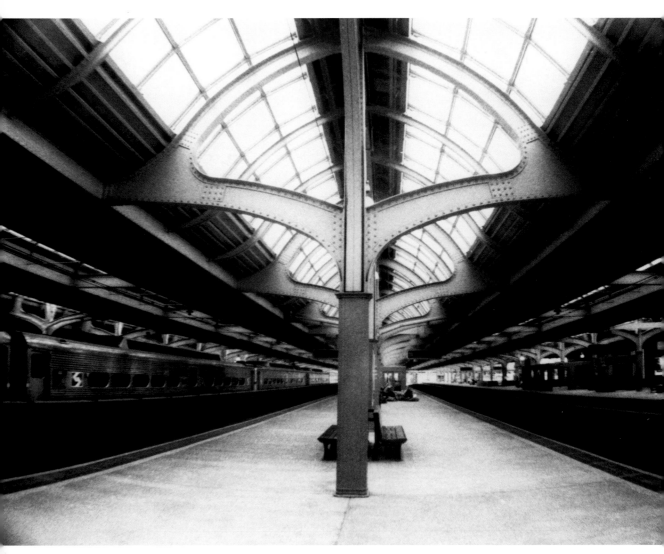

Photograph by Alex Gibbons

Seeing

Looking up, Alex Gibbons was struck by the graceful shape of this roof support at 30th Street Station in Philadelphia, Pennsylvania and the way that the pattern was repeated all the way along the platform.

Thinking

Symmetry was the key to the composition and Alex framed his picture so that the nearest support was exactly in the middle of the picture, with the edges of the platform contributing two strong diagonal lines leading away into the distance.

Acting

The use of a fisheye attachment which screwed into the filter thread of his 35–70mm zoom allowed Alex to move close to the support, while the perspective achieved allowed him to emphasise its importance within the picture while making the horizon appear further away.

Technical Details

35mm SLR camera with a 35mm lens with fisheye attachment and Kodak T-Max 400 film.

Photograph by Alex Gibbons

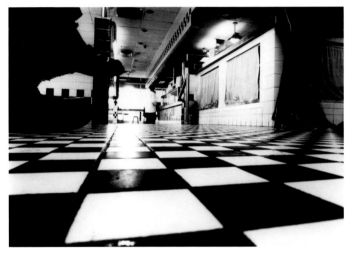

To make a feature of the black and white chequered flooring in this restaurant in Media, Pennsylvania, Alex Gibbons fitted an extreme wide-angle lens, set the aperture to f/22 to give maximum depth of field and placed the camera on the ground so that it would remain steady throughout the 1 second exposure required. The unusual low angle gives this very ordinary setting an almost surreal quality.

Technical Details

35mm SLR camera with a 24mm lens and Kodak T-Max 100 film.

Equipment & Technique

3

It can be very tempting to collect
equipment for the sake of filling the
gadget bag but the best approach is to start with a simple camera and then
to acquire lenses and further accessories as the need arises. Camera gear is
there to serve a purpose and it's important that you understand what
everything can do and know how to make the best
use of it.

Camera Formats

Cameras come in all shapes and sizes and each format has its own particular strengths and weaknesses based around the principles of picture quality and ease of use. The trick is to learn which one most suits your way of working and then to learn how to exploit its advantages to the benefit of your picture taking. You should also keep your mind open at a later stage to other formats and be prepared to switch across at times should the particular situation demand it.

Pros & Cons

The main benefit of the smaller format cameras such as 35mm and APS is that even the SLR versions will be extremely easy to carry around and are often so automated that you can effectively point and shoot, freeing yourself up to concentrate on the picture content. Rangefinder cameras, such as the Leica that was used so effectively by photographers such as Henri Cartier-Bresson, are also very unobtrusive and are ideal for candid studies. Moving on to subjects such as landscape, still life and architecture however, there is less of a requirement for speed and the emphasis is more on quality. Medium or large format can then come into its own, producing a bigger negative size that will yield finer grain and greater detail. Most large format cameras will also offer lens and film-plane movements that can be used for such things as correcting converging verticals in architectural studies and increasing depth of field.

Technical Details
▼ 6x17cm camera with a 90mm lens and Agfa APX 100 film.

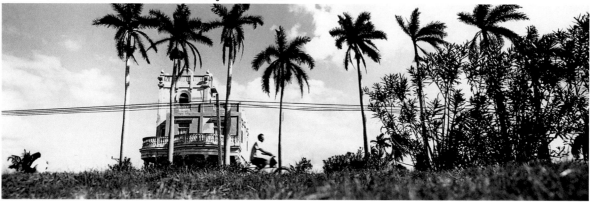

Photograph by Lorenzo DeStefano

Lorenzo decided to make a prominent feature of these palm trees by using a panoramic camera, and waiting for a cyclist to come into the picture to add the necessary final touch.

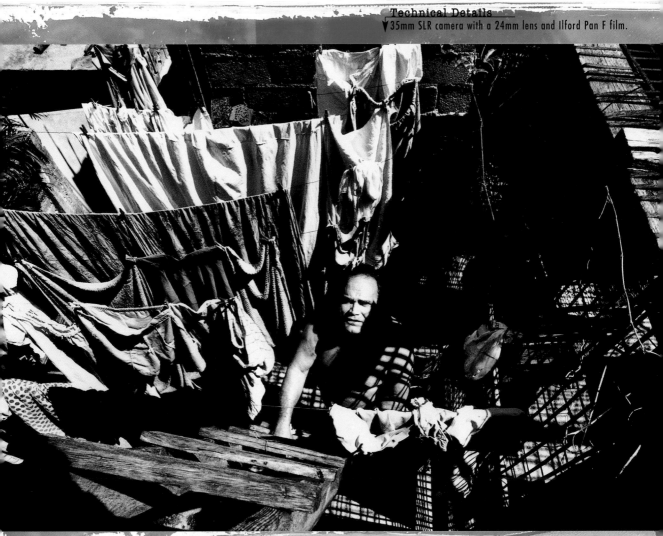

Technical Details
▼ 35mm SLR camera with a 24mm lens and Ilford Pan F film.

Spotting this man hanging out his washing in Santiago de Cuba, Lorenzo DeStefano leaned over and took the picture before the moment disappeared. His 24mm lens ensured that depth of field was such that focusing was not a major issue.

Photograph by Lorenzo DeStefano

Lenses & Their Effects

The lens that you choose won't just help you to include more or less of your subject in the frame, it will also have a major effect on the final look of the picture through the perspective it will enable you to achieve.

Pros & Cons

The standard lens is so called because it achieves a viewpoint and perspective which is similar to that provided by the human eye. The alternatives are long and wide lenses and each will give a distinctive look to a picture. Long lenses don't change perspective but they allow distant objects to be pulled up closer and by doing so create the effect whereby objects seem to be closer together than they actually are. This characteristic can be particularly useful when you want to relate elements to one another that may be some distance apart. Wide lenses on the other hand will exaggerate the scale of those subjects closest to the camera, giving them extra importance in the picture and diminishing the importance of the background.

Zoom Lenses

Improving technology has meant that zoom lenses can now produce results of a similar quality to fixed lenses, while the maximum f-stops featured have also been substantially improved. Photographers can now have all of the advantages of the zoom with virtually no drawbacks. Specialist zooms can cover a huge range, such as 28–200mm, while some of the shorter zooms, around 35–80mm, are now starting to become a real alternative to a fixed standard lens and are far more versatile.

A photographer carrying a 28–80mm and 80–200mm zoom plus a converter that could double focal length will have a huge range of options contained in just three optics.

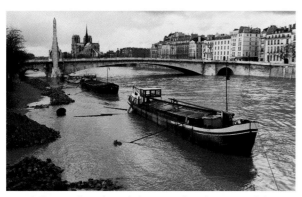

Photograph by Gerard Rhinn

Gerard Rhinn used a wide-angle lens to produce this picture of the River Seine. This optic allowed him to obtain the desired viewpoint and also emphasised the scale of the boat in the foreground, making it a stronger element of the composition.

Right: This illustration shows the varying fields of view for different focal length lenses used with a 35mm camera.

Technical Details
645 camera with a 55mm lens and Ilford FP4 film.

Photograph by Chip Forelli

The use of a wide-angle lens enabled Chip Forelli to move close-in to this cluster of sand daisies. A Hasselblad Flex body allowed him to introduce camera movements to ensure that depth of field extended throughout the frame.

Technical Details
6x6cm camera with a 40mm lens and Panatomic X film.

Shutter Speeds & Apertures

The black and white photographer has several ways to influence the look of the picture that's eventually produced, principally through an understanding and a mastery of camera controls.

Technique

An exposure meter will give you a reading that should produce a well-exposed picture but this is only an indication as to what is required, not a shutter speed and aperture combination that has to be followed to the letter. The same amount of light can be made to reach the film by changing the shutter speed/aperture relationship and this can help you to achieve a particular effect, such as movement within the picture.

The difference between each f-stop and each shutter speed is effectively the same and so, if you alter one to let in one stop more light, you should alter the other to let in one stop less light. As an example, an exposure of 1/125sec at f/8 could become 1/60sec at f/11 or 1/250sec at f/5.6. All three exposures would let in exactly the same amount of light but one setting would give you a slower shutter speed along with a smaller f-stop and more depth of field, which might be what you need for a landscape study. The other would give you a faster shutter speed and a narrower depth of field which, for candid shots, might be exactly what's required.

Slow Shutter Speeds

When there's natural movement in a picture, say water cascading down a waterfall or flowers bending in the wind, you can select a slow shutter speed and capture this on film. It can add life to an otherwise static study and give a wonderful impression of what the scene was really like.

You're restricted to a certain point by the smallest aperture that your lens will offer you, typically f/22 with a 35mm camera, although some studio and vintage cameras can go up to f/64 and beyond. If we take the example of 1/125sec at f/8 once again, the slowest shutter speed you can obtain with the average lens will be 1/15sec at f/22, which may be enough if the movement in the scene is quite dramatic. If you need a slower speed you can choose to change the film speed – for example moving from an ISO 400 film to one that's ISO 200 will give you another stop to play with – or you could fit a neutral density filter.

Chip Forelli shot an initial Polaroid picture to determine the length of exposure needed to record the movement in these waves off the coast of Maine, USA. 1 second was adequate and he achieved this shutter speed with an ISO 400 film by setting his aperture to f/32.

Technical Details
5x4in camera with a 75mm lens and Kodak Tri-X film.

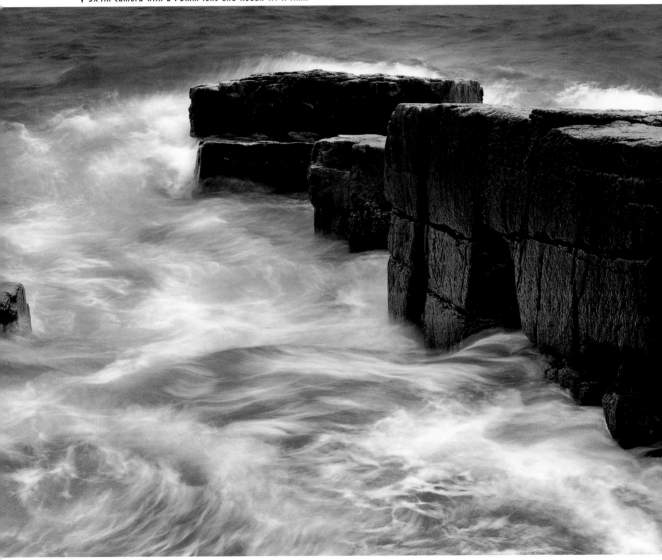

Photograph by Chip Forelli

Shutter Speeds & Apertures

Technique

Working with lengthy shutter speeds carries the danger of introducing camera shake into the picture, which will ruin the effect if the idea is to contrast movement and sharpness in the picture. There are steps a photographer can take to ensure the camera remains completely steady, the most important of which is to invest in a good quality tripod that won't move easily even if the wind is blowing. Another major cause of camera shake is the judder when the shutter is released or, if an SLR is being used, when the mirror flips up. Most advanced cameras will have a screw thread inside the shutter button that allows a cable release to be screwed in, ensuring the minimum of vibration when the shutter is fired. If you don't have this facility then use the self-timer to do the task instead.

Photograph by Chip Forelli

Apertures

Learn to use your camera's stop-down facility if it has one. This is the button that will set the aperture down to the point where it will be when the picture is actually taken – most cameras these days will show you only the scene you'll get with the aperture fully open. The viewfinder will go much darker but you should be able to see how the depth of field is affected by the aperture that you've set and you can then adjust it as necessary should it not be to your liking.

Technical Details
5x4in camera with a 90mm lens and Kodak Tri-X film.

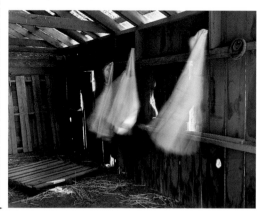

Entering a large barn in Salinas Valley, California, Chip Forelli noticed the wind coming through the open door behind him, which was causing the coats on the wall to move around violently. Realising that he could use this to his advantage he set his camera up on a sturdy tripod and set an exposure of 1 second at f/22 and a 1/2. A yellow filter made the coats stand out more against the dark background.

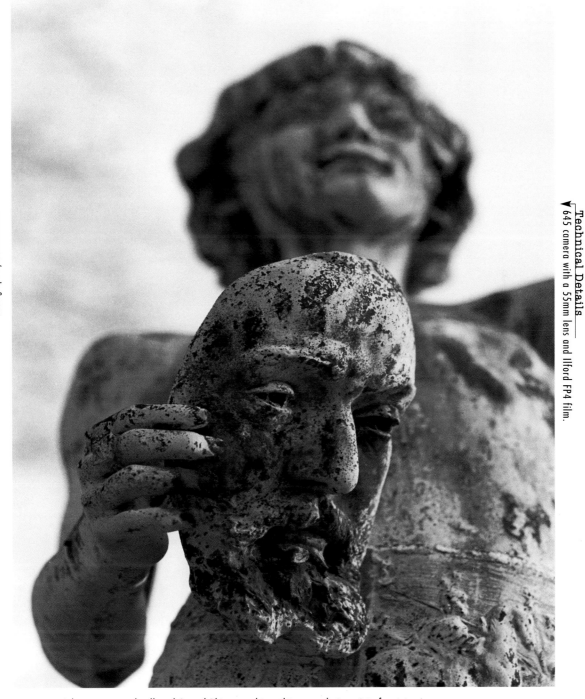

Photograph by Gerard Rhinn

Technical Details
▼ 645 camera with a 55mm lens and Ilford FP4 film.

A low camera angle allowed Gerard Rhinn to achieve this unusual viewpoint of a statue in Luxembourg's Park, Paris. The slightly unreal nature of the study was created by setting an aperture of f/8 and focusing tightly on the face in the foreground, allowing the rest of the statue behind to drift out of focus.

Creative Film Choices

Choice of film is often dictated by the conditions the photographer is likely to encounter but there are times when a particular film will be used because of the feel that it will bring to the picture.

Technique

The quest by manufacturers these days is for black and white films that offer amazingly low grain coupled with **high quality** and, to a certain extent, this restricts photographers who are looking for a particular effect to enhance their pictures. There are other options however. Some specialist films are produced that offer ultra high speed of ISO 1000 (more if pushed) and these will still offer noticeable **grain structure**. Another option is to use a conventional fast film, such as Kodak's stalwart emulsion Tri-X (rated at ISO 400) and then frame your picture so that the area of interest is located in just one small area. A **huge enlargement** will pull up that section of the negative and give you the image that you want but the grain structure will have been considerably increased in size.

Bernard Carrette produced this nude study on a lonely beach in Greece, framing so that his picture became a study in form rather than a portrait of a model, while the sea behind acted as a slab of dark tone with the sky an area of lighter tone above. Wishing to create texture within this part of the picture Bernard opted for Tri-X film, which he processed in Rodinol 1+25 for 9min.

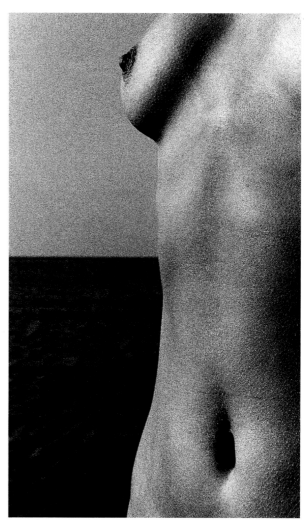

Technical Details — 35mm SLR camera with a 50mm lens and Kodak Tri-X film.

Photograph by Bernard Carrette

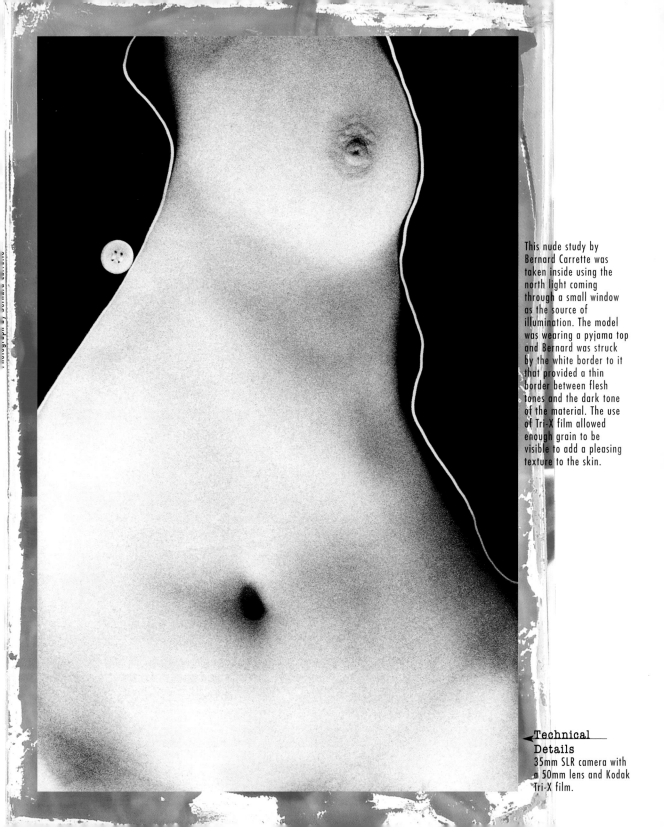

This nude study by
Bernard Carrette was
taken inside using the
north light coming
through a small window
as the source of
illumination. The model
was wearing a pyjama top
and Bernard was struck
by the white border to it
that provided a thin
border between flesh
tones and the dark tone
of the material. The use
of Tri-X film allowed
enough grain to be
visible to add a pleasing
texture to the skin.

**Technical
Details**
35mm SLR camera with
a 50mm lens and Kodak
Tri-X film.

Exposure Control

Mastery of black and white photography has much to do with an understanding of
light and how if affects a scene and, subsequently, how to reproduce its subtleties
within a photograph. A grasp of exposure technique is the key and will be crucial if a negative that
will offer the required range of tones and contrast is to be produced.

Technical Details
▼ 35mm SLR camera with a 35mm lens and Ilford FP4 film.

Photograph by John Benigno

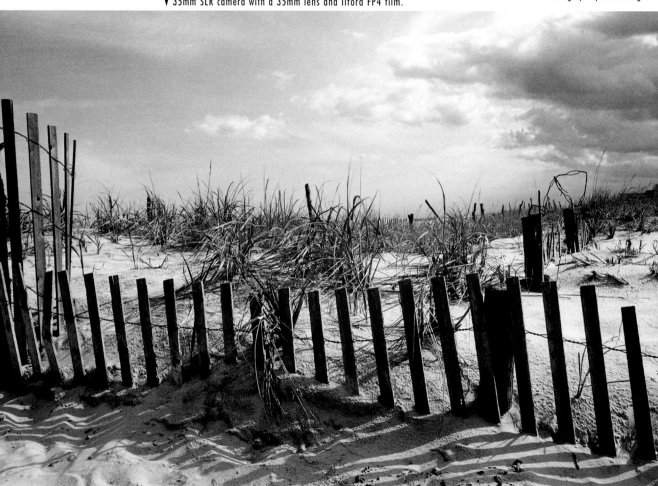

John Benigno came across this scene in Beach Haven, New Jersey as an evening storm was
approaching from the north. A yellow filter was used to allow the sky to darken down and to
appear more threatening and the exposure reading was taken from the surface of the sand to
ensure the shadows along the line of the fence became dense and impenetrable.

Photograph by David Myers

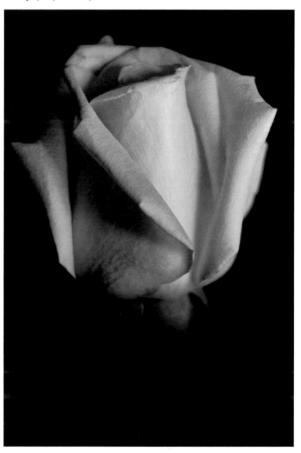

Technique

A light meter will calculate an average exposure that will suffice for most situations, particularly when using black and white film which has enormous latitude. The more advanced photographer, however, can introduce more discretion to cater for times when the lighting being faced is more complex. If looking towards the light, for example, the meter will be fooled into indicating underexposure. Conversely a scene that is full of dark tones may well be overexposed. Ways of getting around this problem include taking an incident light reading, that is to say to measure the light falling on the scene rather than that reflecting from it, or to place a grey card within the scene and to measure the light from that point so that exposure is taken from an average tone.

It's also possible to use a spot meter, which will measure light precisely from several chosen areas within the scene and then will calculate an average exposure from this.

Breaking the Rules

Once an understanding of light has been gained, the old chestnut about working with the sun over the right shoulder is there to be disobeyed. Far more dramatic effects can be achieved by looking towards the light source or by shooting at the start and finish of the day when the sun is low in the sky, the light is harsh and contrasty and shadows are long. Black and white is all about tones so learn to see how the light is changing constantly with the position of the sun and use shadows as dynamic elements within your composition.

David Myers photographed this rose in his studio for a self-assignment. Setting up a black background to highlight the lighter tones of the bloom, he then had to measure the light falling onto the scene. This was in order to avoid his meter being fooled into suggesting overexposure by the scene's low-key nature.

Technical Details
6x7cm camera with a 200mm lens and Agfa APX 100 film.

Using Natural Lighting

Even working indoors there is no reason why available light can't be utilised for photography. It has a fantastic quality and can be used to create moody and atmospheric effects.

Pros & Cons

Using natural light inside is a challenge but it's one that is worth meeting, because it can provide the basis for some wonderful pictures. You'll have less control and will have to learn to work around slower shutter speeds and less reliable conditions but, provided you're willing to watch the way the light works for you and have the initiative to make the most of what it can offer, it can be some of the best light you will ever encounter.

The classic position for any subject being lit by natural light indoors is close to a window, being hit by strong sidelighting. Here you have a few options: you can work with the light as it is, because this kind of dramatic modelling can be highly effective, creating areas of light and shade around a face and revealing character; or you can tone the effect down a little if the look is too severe, using something large and bright such as a sheet, to bounce light back into the shadow areas. The latter is a simple technique and the beauty of it is that you will be able to see on the spot how much light is being thrown back.

Realism

Another option is to ask your subject to turn their head so that they are looking towards the light. This approach avoids eye contact, which is a useful benefit for some kinds of portraiture and it also allows the face to receive light that's more full-on, which takes away the shadows.

Exposing for the highlights darkens down surroundings and allows clutter that may be behind the subject to be effectively removed from the scene. The air of realism that comes from a feel that's decidedly natural is another plus point and, as a way of working, it's more relaxing and informal than a traditional studio environment.

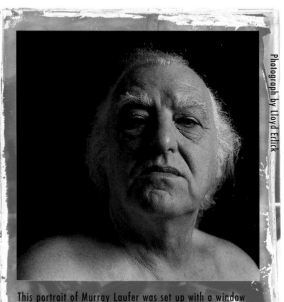

Photograph by Lloyd Erlick

This portrait of Murray Laufer was set up with a window close to Murray's left. A white sheet was held close to him just out of camera shot on his right side, and it bounced light back into his face and added some detail there.

Technical Details

6x6cm camera with a 120mm lens and Kodak T-Max 400 film.

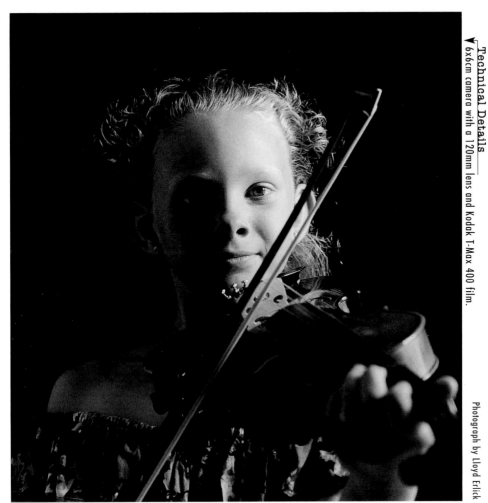

Technical Details
6x6cm camera with a 120mm lens and Kodak T-Max 400 film.

Photograph by Lloyd Erlick

This image was one of a series made by Lloyd Erlick for his series 'Children Coming and Going'. Reba was placed close to a window and the light picked out one side of her face very strongly, drawing attention to her eye. A very weak light was thrown back into the shadow on the other side of her face by the use of a white sheet held some distance away.

Studio Lighting

Although daylight can work well inside it ties the photographer into shooting only at certain times of day. Studio lighting can open the door to a more flexible way of working and also presents an opportunity for creative lighting to add its very own signature to an image.

Pros & Cons

Studio lighting comes in different shapes and forms but basically breaks down into bulb lighting and flash. The former has the advantage of being able to give a good indication to the photographer of where light will fall and how it will react with the subject, but it can be cumbersome to use and could make the studio uncomfortably hot. Flash is the preferred option of most studio photographers, because it's small and flexible and is fast enough to freeze most movement. Studio flash will usually feature a modelling light that will give an indication of where the light is going to fall, but the only way to tell for sure what is going to happen is to shoot a test Polaroid beforehand.

Technique

There's no reason with black and white photography, why light sources shouldn't be mixed. Different types of lights can be used in conjunction with each other, such as flood lamps and flash heads, or softboxes and spotlights. You can use a single powerful source like a flash head to provide extra light from one particular direction if you want to highlight a certain area of your subject. To temper intensity of light where necessary, sheets of diffusing materials can be used in front of the lights.

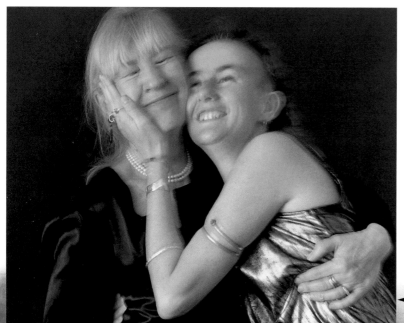

This picture of mother and daughter was lit in exactly the same way to the picture opposite but this time Lloyd Erlick anticipated that his subjects might be more animated, and he decided to make this a feature by setting a slow shutter speed of 1/15sec. Because he was using a combination of four photo flood lamps and a 500W flash for this picture this meant that a long exposure would pick up both ambient light plus the flash and the result – captured as the daughter informed her mother (on camera) for the first time that she was pregnant – was a lively mix of blur and sharpness.

◀ Technical Details
6x6cm camera with a 120mm lens and Kodak T-Max 400 film.

Photograph by Lloyd Erlick

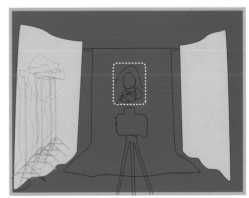

Lloyd Erlick used a combination of flood lamps and moderate power flash to light this portrait, directing his lights at his subject from the left of the frame and softening their effect by erecting a white fabric diffuser just in front of them. Another white fabric diffuser was placed just out of view to the right of the frame to create a soft fill on the left-hand side of the subject's face. A seamless black paper backdrop helped to provide a neutral and pleasing background.

◄**Technical Details**
6x6cm camera with a 120mm lens and Kodak T-Max 400 film.

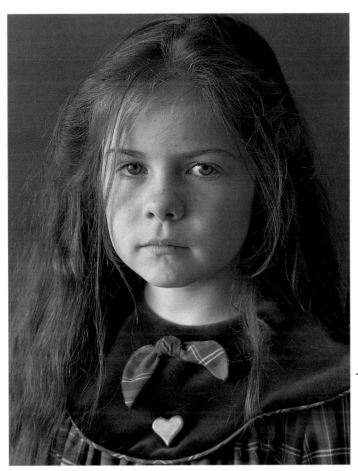

Photograph by Lloyd Erlick

Using Filters

An understanding of the benefits of filters is vital for the black and white photographer, because it will give them extra control over the way that a scene is recorded onto the negative.

Technique

Daylight is composed of many different wavelengths and the job that a filter will do is to absorb some of these while transmitting others. The effect of this is to lighten or darken certain tones within the final black and white image and this can be used to add drama to a scene or to add emphasis to a particular area. The most common filters to be used by black and white photographers are yellow or red – which will have the effect of allowing areas of blue, such as the sky, to become very dark while lightening areas of yellow – and green, which will make areas of foliage much lighter while also darkening the tone of a blue sky and any areas that are red. Other filters that are worth considering include graduated sky filters, which are colourless at the bottom and become increasingly yellow dyed towards the top to enable skies to be selectively darkened, and polarising filters, which will allow the intensity of reflections in non-metallic surfaces, such as water, to be greatly reduced and will also darken blue skies.

Technical Details
▼ 6x7cm camera with a 55mm lens and Kodak Plus-X film.

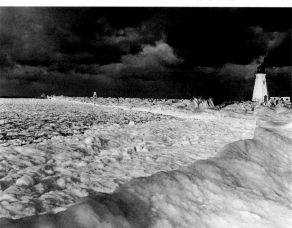

Photograph by Libor Jupa

Above: Libor Jupa encountered this wintry scene close to his home in Ontario, Canada, and he emphasised the contrast between the white of the snow and a glowering sky by using a yellow filter that caused the blue in the scene to darken down considerably.

Right: This view of Lake Ontario was taken by Libor Jupa, who used a neutral density filter to allow a shutter speed slow enough to cause the clouds and the water to take on a misty, almost ethereal appearance. This filter is used to cut down on the light reaching a film by a stated amount and will absorb all wavelengths almost equally, ensuring that there is no influence on the tones each colour will record, as there is on black and white film.

Technical Details
▼ 5x4in camera with a 210mm lens and Kodak Tri-X film.

Photograph by Libor Jupa

Using Filters

Technical Tip

If you are not using a camera with through-the-lens metering it's important to realise that there will inevitably be a filter factor that needs to be taken into consideration. This is the amount the exposure will need to be increased by to compensate for the use of a filter. A x2 filter requires one stop extra exposure, a x3 one-and-a-half stops more, a x4 two stops more and so on.

Technical Details

▼ 5x4in camera with a 90mm lens and Kodak Tri-X film.

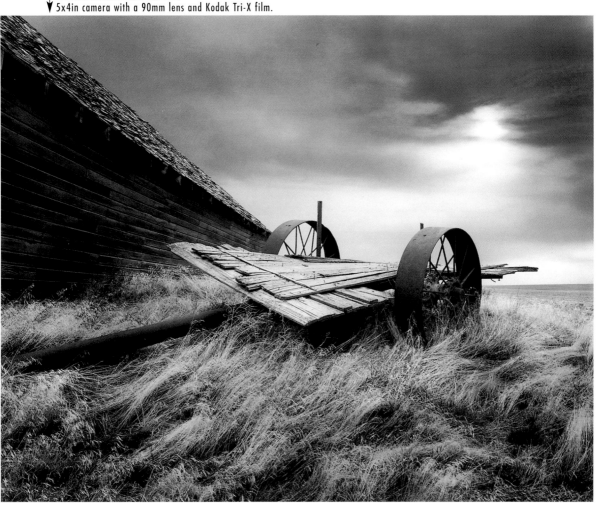

Photograph by Chip Forelli

A twisted old cart discovered by Chip Forelli on a farm in Douglas County, Washington State, made an intriguing subject for a picture. A wide-angle lens was used to emphasise its importance within the frame. Chip then used a yellow filter to add some more tone to a rather bland sky.

6x6cm camera with a 100mm lens and Panatomic-X film.

Photograph by Chip Forelli

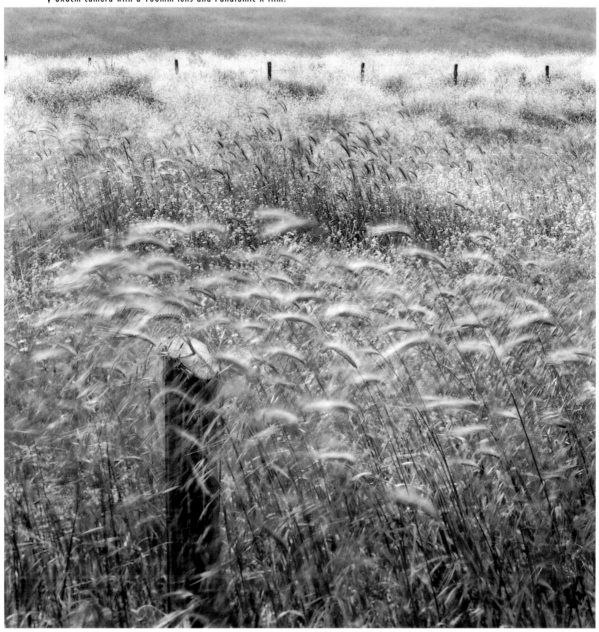

The movement of wheat stalks as they were blowing wildly in the wind was the
subject of this picture by Chip Forelli. He used a yellow filter to lighten the tone of
the crop and to emphasise the subject blur.

Using Filters (Infrared)

Black and white infrared film is sensitive to wavelengths that the human eye can't see and will reproduce a scene as a surreal mixture of tones which can be highly effective.

Technique

Infrared film will need to be used in conjunction with a red filter to filter out all the blue light and to make sure that only red (or indeed infrared) light reaches this film. There are primarily three to choose from:

Wratten #87 opaque red. This filter will cut out all the visible light and only allow infrared light to reach the film. Using this filter produces the most dramatic effects.

Wratten #89B opaque red. This is similar to the #87 but is not totally opaque so that, on a bright day, it is possible to see through the lens.

Wratten #25 red. This is by far the easiest filter to use because it's possible to see through the filter and to compose in the normal way. The results, while not as dramatic as those obtained with a #87, are still very pronounced.

Technical Tip

When using the Wratten #87 filter you will not be able to see anything once it's attached to the lens because the filter is effectively opaque. To compose you will need to mount the camera on a tripod, set the image up and only then attach the filter and shoot your picture.

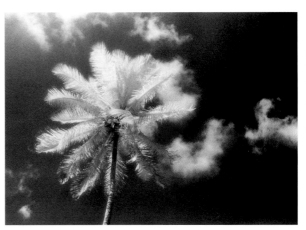

Photograph by Andy Finney

Spotting this palm tree outside his hotel in Cuba, Andy Finney looked directly up at it so that he achieved an unusual composition where the top of the tree was framed directly against the sky. The leaves of the tree were turned almost white while the deep blue sky went almost black, providing a highly effective contrast. The picture was shot through a Wratten #25 filter.

Technical Details
35mm SLR camera with the 35mm end of a 35–80mm zoom lens and Kodak High Speed Infrared film.

Travelling through Cuba Andy Finney came across this vintage
American car in a side street and thought that it would be the perfect
subject for an infrared picture. He shot through a Wratten #25 filter
and rated the film at ISO 50.

Photograph by Andy Finney

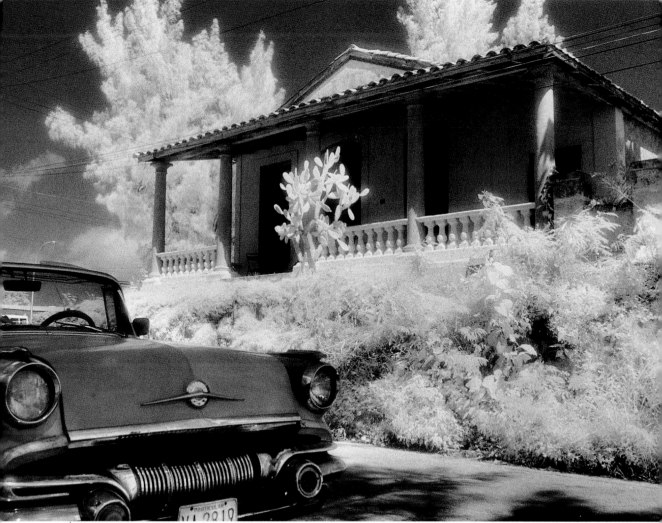

▲Technical Details
35mm SLR camera with the 35mm end of a 35–80mm zoom lens and Kodak High Speed Infrared film.

Using Filters (Infrared)

Spotting that the cloud formations were perfect for his requirements, Robert Howells set up this picture of a dead oak tree that he'd passed many times. He rated the Kodak High Speed Infrared film he was using at ISO 200 and shot through a Wratten #89B filter.

Technical Details
▼ 35mm SLR camera with a 28mm lens and Kodak High Speed Infrared film.

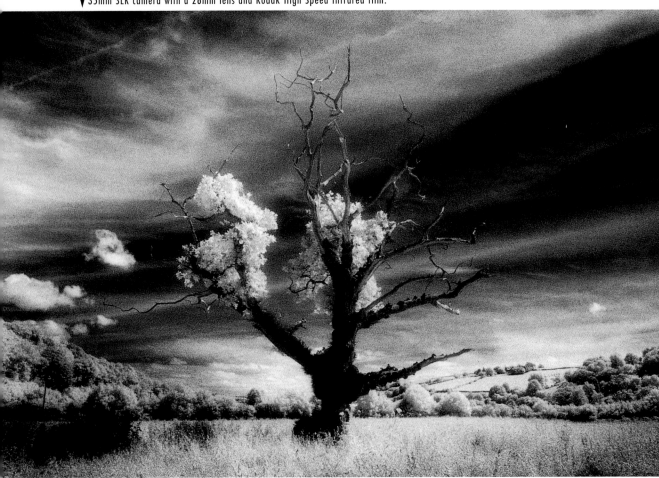

Photograph by Robert Howells

Rule of Thumb

The use of Infrared film can be a little hit and miss
because the amounts of invisible infrared light vary from
time of day to time of year, and there are also other
variables such as the amount of cloud cover that is
present. This means that it's wise to bracket exposures by
at least plus or minus one stop either side of the meter
reading to ensure a perfect result.

Printing Technique

These prints were made by the split grade method,
which is used to vary the contrast of the image by
altering the grade at which it is exposed. Using a
multigrade paper, the picture of the
church was exposed at grade 3 and then filtration
was changed and selected areas were burned in
using grade 5, the higher contrast making sure
that the subtle highlights in the grass were retained.
By darkening down the lower part of the
image and the edges, Robert determined that the
main focus of attention would fall on the church. The
print was subsequently toned in thiocarbamide.

Technique

Those wishing to use infrared materials will find that there
are several unusual conditions that need to be observed. Firstly
the film usually needs to be loaded and unloaded
from the camera in darkroom conditions, because light will be
able to penetrate the film cassette and will fog the film. Film
such as Kodak's High Speed Infrared material also has no
nominal ISO rating and so photographers will need to
experiment with exposure/development to ascertain the
'correct' exposure index (ISO rating) for their way of working.
Infrared also focuses at a slightly different point to the visible
spectrum and so you'll either need to set a small f-stop
to increase the depth of field or adjust the focus to the
red mark which is usually provided on the barrel of
interchangeable lenses.

Technical Details
▼ 35mm SLR camera with a 28mm lens and Kodak High Speed Infrared film.

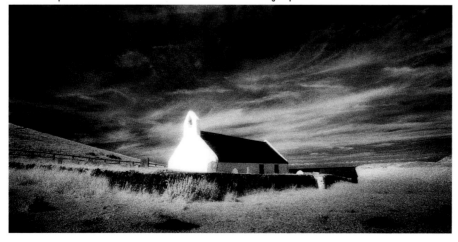

This shot of Mwnt
Church was taken by
Robert Howells as
part of a project to
capture the Welsh
landscape through the
medium of Infrared.
He fitted a Wratten
#25 filter to his
camera and rated the
Infrared film he was
using at ISO 640.

Photograph by Robert Howells

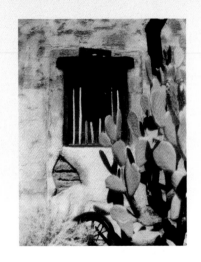

Processing & Printing

Photographs by Debi Scott

4

The real joy of black and white is the control
you will have over the final print in the
darkroom. All kinds of effects can be achieved through the use of printing
and toning techniques and you'll have a real sense of having been involved
in the image through every stage of its production.

Home Darkroom

The darkroom doesn't have to be a permanently dedicated space. Many photographers have improvised and adapted rooms on a temporary basis and it's perfectly feasible to do this and still produce high quality prints that bear the hallmark of your personal input.

Not every room is suitable, however. The best by far, so long as you follow safety precautions, will be the bathroom, because this is set up for hot and cold running water and will generally be easy to black out and to clean later on. The kitchen can also be adapted because this will also have a water supply, but you must be extra vigilant to clean up completely afterwards in order that no surfaces will be contaminated.

The first step is to seal all windows, either with a thick sheet of material or card that can be taped down at the edges or with a board that can be hung in position and removed easily later on. You will probably also want to hang material across the door once you're inside to make sure that no light leaks in around the edges there and you'll need to switch your normal light bulb for a safelight, probably either red or yellow.

Set up your enlarger on a solid surface and make sure that you have enough space above it to allow for the vertical movement necessary when its use is required. Power will probably have to be supplied through an extension lead since plug sockets are barred from bathrooms, so make sure that you keep this well away from any liquids and always dry your hands before going back to make another print.

Line your dishes up alongside one another close to running water and drain facilities. An ideal position would be sitting on top of a piece of board placed across the top of the bath so that any splashes aren't serious. Make sure that you have extra trays of clean water between each stage of the printing process so there is no cross-contamination of chemicals, and open the door at regular intervals to make sure you keep the air in your darkroom as fresh as possible.

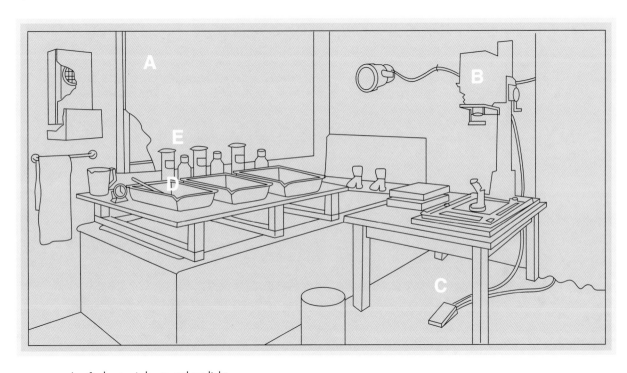

A – Card over window to seal out light
B – Enlarger
C – Extension lead for power
D – Processing trays
E – Chemicals for processing

Film & Paper Processing

There are all kinds of different formulas for film and paper developers and each will have its own particular attributes – for example the production of extra fine grain or added contrast – that those seriously getting into the darkroom will eventually need to make themselves aware of. There are, however, also some very good standard developers, such as Agfa's Rodinol, that will suffice as an excellent starting point.

Other chemistry that those entering into the darkroom will need include fixer – there are different solutions for film and paper and it's best to use the one recommended for the material that you're using – and a stop bath solution that will need to be diluted as instructed before use. It would also be wise to use wetting agent for the final rinse of both films and papers because it discourages the formation of watermarks and speeds drying.

The golden rule for chemistry of all kinds is to follow instructions to the letter, to use them at the correct temperatures to make sure that they perform as they're intended and to discard solutions when they're less than fresh. A priceless film could be ruined by the use of a stale developer or a life-expired fixer, so make sure you check out use-by dates before use.

Cleanliness

The greatest threat to the efficiency of the chemicals that you're using is contamination, so cleanliness is particularly important. Keep bottles sealed and well away from each other and while processing make sure that there is a thorough wash between each stage.

Specialist Chemistry

There are times when chemistry that is not particularly recommended for a material can be used to stunning effect. One of the best examples is the processing of conventional printing papers in lith developer. The result will change according to how life-expired the developer happens to be, but characteristically it will give the print a very pleasing pink tone.

This portrait of a baby was made by Darin Boville using
a torch to 'paint-in' the light. Those who set up their own
darkroom will be able to claim overall control of every
stage of the picture's production.

Photograph by Darin Boville

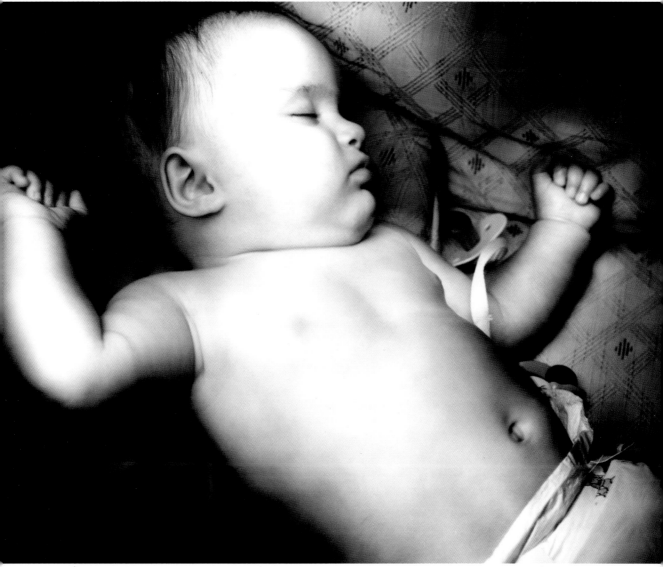

▲ Technical Details
5x4in camera with a 135mm lens and Kodak Tri-X film.

Developing Film

Even those who don't possess full darkroom facilities will be able to process their own films thanks to the excellent range of daylight developing tanks that are on the market. All that's required is a small light-tight area where film loading can take place and then every other step can be carried out in room lighting.

Loading the Film

This is probably the most nerve-wracking and difficult part of the operation but, when you've accomplished your first film, you'll acquire the confidence to move on from there. A good idea is to use a scrap film and to practise loading in daylight conditions at first to get the feel of it, and then progress to loading this film in the dark. Only when you're confident that you can load the film successfully and without any creases should you move onto the real thing. You should also always make sure that the spiral you're using is absolutely dry, because if it's damp it will make loading a film very difficult.

Processing

It's often best to use what's known as a one-shot developer, where a concentrated solution will be diluted, used once and then discarded. This ensures consistency of results and is a very simple way to work. Stop bath and fixing solutions have a longer life if kept stored in an air-tight container and can be used several times.

When processing is complete use a drop or two of wetting agent to help the film to dry without any watermarks. You can also, if you're careful, wet two fingers and slowly draw them down the film to remove excess moisture and this will help it to dry more quickly. Hang the film somewhere where there's a good air flow but no danger of dust and attach a peg or bulldog clip to the bottom so it hangs straight. Some photographers will use a hairdryer to speed up the drying process but this does increase the risk of dust attaching to the film.

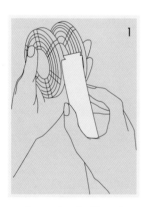
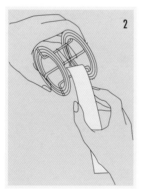

1 and 2. Loading the film in the spiral is a straightforward operation, particularly if you're processing 35mm. The film is fed into the centre and then twisting the spiral will pull the film in. Once you're satisfied that it's successfully loaded you place it inside the tank. Some tanks have space to hold several films and once they're all in place the top can be screwed tight and the lights can be turned on.

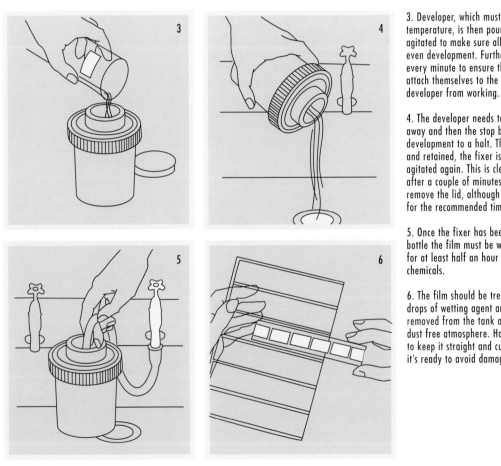

3. Developer, which must be at the correct temperature, is then poured into the tank and is agitated to make sure all of the film is receiving even development. Further agitation must follow every minute to ensure that no air bubbles attach themselves to the film and prevent developer from working.

4. The developer needs to be poured quickly away and then the stop bath is added to bring development to a halt. This is then poured out and retained, the fixer is added and the tank is agitated again. This is clearing the film and, after a couple of minutes or so, it will be safe to remove the lid, although fixing must continue for the recommended time.

5. Once the fixer has been poured back into its bottle the film must be washed in running water for at least half an hour to remove all trace of chemicals.

6. The film should be treated to a couple of drops of wetting agent and then can be carefully removed from the tank and hung up to dry in a dust free atmosphere. Hang a weight on the end to keep it straight and cut and bag it as soon as it's ready to avoid damage.

Specialist Prints & Toning

Having the ability to tackle your own printing opens up all kinds of possibilities and many alternatives to the conventional black and white silver print are possible.

Toning

The simplest tones are two bath affairs, where the first bath is a bleach that will take away the strength of the picture and reduce it to a washed out image, and the second is a tone that will bring it back up to full intensity but with the black tones replaced by a colour such as yellow or blue. It's a very simple process and one that can be carried out in full room lighting, but there are an amazing amount of ways a photographer can influence the result that is achieved. For a start the print doesn't necessarily have to be bleached back the whole way and, by removing it at an intermediate stage and then toning, the intensity of the colour that's achieved will be affected.

The toner itself, which is made up of a mixture of different chemicals, can have its constituents played around with so that the colour of the tone will vary. With thiocarbamide toner, for example, any colour from dark brown to yellow brown can be achieved by varying the relative strengths of its ingredients. Another way that toning can be affected is for a split-tone technique to be used. After bleaching the print is placed in a toner but then removed before it's fully toned, and washed and placed in a toner of a different type. A split sepia/blue tone, for example, can be highly effective, with highlights taking on a brown cast while shadows are deep blue.

Speciality Prints

More and more photographers are looking back to photography's past and rediscovering the pictorial qualities of some of the early printing methods. It's even possible for photographers to make their own emulsions and to produce, fairly easily, hand-made salt or albumen prints that are exposed, in time-honoured style, by the action of the sun. One of the print processes most favoured by fine art photographers is the platinum/palladium print. Invented in the early 1870s this is a convoluted process using, as its main constituents, potassium chloroplatinate, palladium chloride and sodium chloride, and it's one that is time consuming to carry out. Because it relies so heavily on the personal touch, however, with each print usually being individually prepared by the photographer, it establishes the credentials of the prints as genuine art pieces, and prints such as this are capable of fetching high prices.

Photographs by Kerik Kouklis

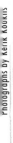

Fine art photographer Kerik Kouklis titles this picture 'Mist and Reflection, Silver Lake, California' and made this platinum/palladium print himself, applying the emulsion to a sheet of Arches Platine paper.

Technical Details
7x17cm panoramic camera with a 14in lens and Ilford FP4+ film.

Kerik works exclusively with a Korona 7x17cm Banquet camera, with which he took this picture of the Rancho de Taos in New Mexico, a church made famous by the pictures of Paul Strand. The picture was produced as a hand-made platinum/palladium print.

Technical Details
7x17cm panoramic camera with a 14in lens and Ilford FP4+ film.

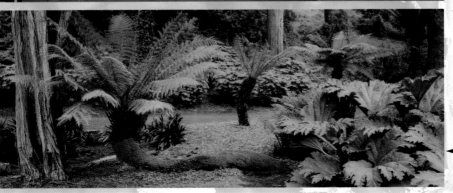

This is an image from Kerik's series entitled 'Land Ethereal', and it features ferns in the Golden Gate Park in San Francisco. The hand-produced platinum/palladium paper used has resulted in a warm colour, smooth tonal scale and a distinct luminosity.

Technical Details
7x17cm panoramic camera with a 14in lens and Ilford FP4+ film.

Hand-colouring

Technique

These days the idea of **hand-colouring** a black and white photograph is not normally to mimic a colour image but to create a picture that, while obviously having **monochrome** origins, mixes colour and black and white elements in a pleasing and original way.

Specialist photographic colouring kits are widely available and these provide the ideal starting point. From here it's down to the photographer to choose their own route: sometimes a **subtle** approach can work particularly well, with perhaps just one or two **details** around the print picked out to add interest, while at other times the bulk of the picture can be coloured leaving few of the original black and white **tones** visible.

A range of **brushes** should be utilised and colours can be mixed or diluted in a white saucer to achieve the desired tones. As a further guide to the **colours** that will be achieved you could produce the prints to be worked on with a wide border – to be trimmed later – and use the area to see how colours will react to the **paper surface**.

Photograph by Ed Krebs

For this last shot in a portrait session, Ed Krebs asked the model to bare her shoulders and he then moved in close for this intimate shot. It still lacked something, but a touch of added colour has lifted the picture considerably. Ed began by sepia-toning his print to add a touch of base colour and then used water-based retouching dyes for the beads and Marshall's Oils for the rest of the picture.

Technical Details

35mm SLR camera with a 50mm lens and Agfapan 400 film.

Prints to be worked on should have a matt or satin finish – a glossy finish will repel the inks – and it's always best to start with a scrap print so that you have the chance to practise your technique and know exactly where to place your colour before starting on a good quality print. Keep a piece of absorbent tissue handy so that any errors can be removed quickly and allow sections of colour to dry before attempting to add further colours to adjacent areas to avoid bleeding edges.

Applying the Dyes

When adding water-based retouching dyes and oils to colour a picture, always start with the dyes and only add the oils when you've completed this stage. This is because water-based products will simply form into beads if oils are already present, as they cannot penetrate the oils to reach the paper. Ed Krebs often uses dust-spotting dyes for small details because he can apply these with a fine brush instead of a cotton swab. The dyes dry very quickly and it's then possible to apply oil paints over the top of them, with the dyes showing through the oils. At this point swabs or an eraser can be used to remove the oils from the detail areas and the dyes will remain.

Photograph by Ed Krebs

Ed Krebs, who can be seen framing his picture in the middle of the bumper reflection, shot this vintage Chevy in a parking lot. Ed took enormous care to add the correct colours to the elements reflected in the car's chrome bumper as well as a base metallic colour to this section of the picture.

▲Technical Details
6x6cm camera with a 75mm lens and Fujifilm Neopan 400 film.

Dodging & Burning

One of the great attractions of black and white photography is the amount of control that can be exerted in the darkroom over the final appearance of a print. Through mastery of dodging and burning techniques it's possible to add exposure or to take it away from selected areas of the picture, helping contrast to be evened out and, on occasions, drama to be added to an otherwise uninspiring scene.

Dodging

Dodging is the name given to the technique which involves **holding back** some of the light reaching a selected area of a print during exposure, in order to **lighten** its final appearance. This might come in particularly useful when, for example, a subject's face is in deep shadow. Holding back light just from this area while allowing the rest of the print to receive its full **exposure** would even up the contrast and allow the face to hold more detail. The trick is to make things look natural and so there should not be any obvious lines around the area that's been dodged. A useful tool you can make is a piece of **roughly torn opaque card** mounted on the end of a length of thin wire. Moving this into position during exposure will allow an area to be held back, the correct amount of coverage being determined by moving the tool closer to or further away from the enlarger. By **moving** the card constantly, edges will be **softened** to the point where they should be invisible.

Burning

Burning is the opposite of dodging in that it's the technique where **exposure** is **added** to selected areas to increase density. This could be useful where, for example, an insipid sky could benefit from an **increase** in **tone** or an area of highlight won't achieve the correct density without the rest of the print darkening down to an unacceptable degree. The tool that comes in useful here is a sheet of **thick card** with a **hole** roughly torn out of the middle. Moving this closer or further from the enlarger will again determine the amount of light passing through and this will allow light to be directed to the area where it's required. Once again, **moving** the card constantly during exposure will make the effect difficult to detect.

Technique

Because you want to have a reasonable amount of time within which to carry out your dodging and burning you should set the enlarger's aperture to a point where the **exposure** for the print is at least in the region of **ten seconds** or so. Typically you might then decide to hold back or to burn in an area of the print for around **three** to four seconds.

Dodging techniques

Burning techniques

Photograph by Youry Vinetsky

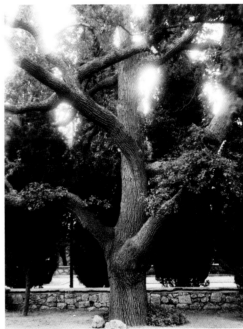

The light in the evening sky was streaming through the upper branches and was still bright enough to create bleeding in several areas. Youry Vinetsky could, however, have chosen to burn in these areas at the printing stage and this would have given him a more balanced effect.

▲ Technical Details
6x7cm camera with a 135mm lens and Svema 100 film.

Printing

Achieving the required print from any negative is one of the skills that black and white photographers will need to learn and, with experience, it's possible to have an enormous influence through work that is carried out in the darkroom.

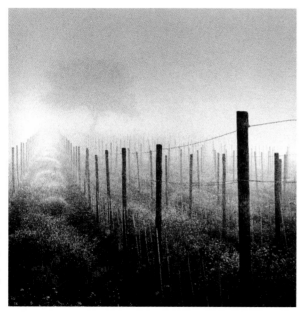

Photograph by Chip Forelli

Visiting a vineyard in Tuscany at dawn, Chip Forelli discovered that a delicate early-morning mist had enveloped the area. Determined to capture the effect on film he shot two rolls of film without bracketing because the fog was changing constantly and he was afraid that the perfect scene would be captured only on a negative where the exposure was incorrect. In the darkroom extra tone was added to the sky by burning in this area of the picture for a few seconds longer.

Technical Details
6x6cm camera with a 100mm lens and Kodak Tri-X film.

Technique

The first stage with printing is to set up a comfortable and clean environment. You may be involved in producing prints for several hours at a time and it will be a much more pleasant experience if you're working in the right conditions. Use a fine brush or a can of compressed air to remove particles of dust or hairs before you start, and check the image on the baseboard with a focusing magnifier to ensure that the grain is in sharp focus. Once you're happy with the size and crop of the image you should stop down the lens of the enlarger by around two stops to achieve the ultimate quality.

At this point you should determine the correct exposure to give the print and so you'll need to produce a test strip. Place this on the baseboard, making sure that it covers an average area of the picture, and then make exposures at five-, ten-, 15- and 20-second intervals. Once this is processed you should be able to establish where your exposure should fall. You can then expose further test strips if required to discover how much extra or less exposure certain areas will require for you to achieve a balanced print.

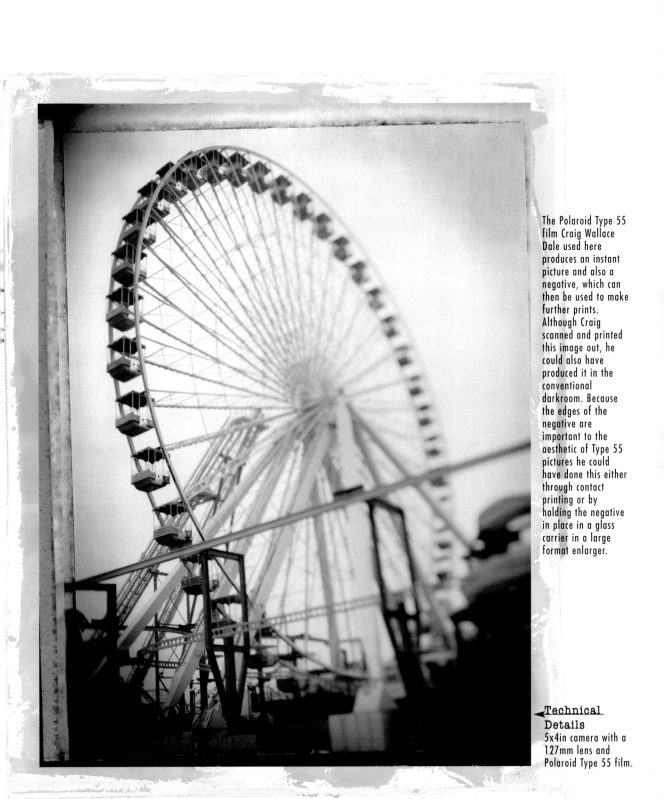

The Polaroid Type 55
film Craig Wallace
Dale used here
produces an instant
picture and also a
negative, which can
then be used to make
further prints.
Although Craig
scanned and printed
this image out, he
could also have
produced it in the
conventional
darkroom. Because
the edges of the
negative are
important to the
aesthetic of Type 55
pictures he could
have done this either
through contact
printing or by
holding the negative
in place in a glass
carrier in a large
format enlarger.

◄ Technical
Details
5x4in camera with a
127mm lens and
Polaroid Type 55 film.

Printing (Contrasts)

Pictures can be printed in different ways in order to achieve
the effect that is desired and contrast has a huge role to play
in this, either being played up or smoothed out in order to present a
particular feel that the photographer desires.

Technical Details
▼ Rangefinder camera with a 60mm macro lens and Kodak Tri-X film.

Photograph by Lloyd Erlick

This print was one of a limited edition of five made to 16x20in size by Lloyd Erlick on Ilford's glossy warmtone (MGW) paper. It was made with an enlarger equipped with a dedicated black and white variable-contrast light source: first a base exposure was made at a moderate contrast setting, followed by a second, shorter exposure at the maximum contrast setting. The second exposure, where it is blocked by the density of the negative's highlights, causes no change in the print in 'normal' areas (often skin tones in portraits). In the areas of the print that receive light through the shadow areas the second exposure isn't blocked and the paper receives more exposure and becomes denser.

Photograph by Lloyd Erlick

Produced on Ilford's glossy warmtone (MGW) paper, Lloyd Erlick made this print from a negative that was slightly underexposed and which would, had it been printed conventionally, have yielded a flat lifeless print. To boost contrast Lloyd adjusted his enlarger's dichroic filters so that his multigrade paper gradually changed from grade 2 to a harder grade, and he then made a series of test prints until he had reached the look he was after, by which point his paper was around a grade 3. The print was then toned in selenium, which he used to achieve a 'chocolate-brown' finish, and this in turn gave the print a far warmer appearance.

The Digital Darkroom

Even those using black and white film can't afford to overlook the possibilities created by the latest technology. The digital darkroom, where manipulation of an image is carried out on the computer screen rather than in the confines of a conventional darkroom area, is now an everyday reality for many photographers.

Technique

The computer, in alliance with a swathe of manipulation software such as PhotoShop, PaintShop Pro, MGI Photosuite and Adobe Photodeluxe, has opened up a huge range of possibilities to the photographer, even those still using conventional cameras and film. Use of a scanner allows negatives or prints to be digitised, at which point it's possible to treat the image exactly the same as a file from a digital camera. Following any manipulation work that is required, the final result can either be saved to a disk and taken to a lab for printing or printed out at home, using one of the excellent photo quality home printers now widely available. Virtually all of the printing effects, such as dodging and burning, toning and multiple exposure, that can be achieved in the silver halide darkroom are possible with the computer. A degree of computer literacy coupled with a willingness to experiment is called for if the most is to be achieved through this method, but guidelines are provided with all software packages and these provide a useful starting point from which to work. Those who go down the digital route enjoy the fact that they can work in daylight and break and come back to their images at any time.

Photograph by Adrian Davies

Adrian Davies felt the original image of this owl was rather dark, lacking in contrast, and rather soft and he decided to make some improvements using PhotoShop software. Firstly the image was converted to 'greyscale' mode and it was then brightened and the contrast increased using the levels and curves control within PhotoShop. Two copies of the image were then made and stored as 'layers' in PhotoShop (1). On one layer the image was sharpened with the Unsharp Mask filter and on the other copied layer the image was blurred (2). A 'layer mask' was placed on each copy which masked the effect of the filters. This black mask was then coloured through with white 'paint' by a soft-edged brush tool to reveal either the sharpening or the blurring of the image. In this way the owl was sharpened while the background was blurred (right).

▲ Technical Details
35mm SLR camera with a 105mm lens and Fujifilm Velvia film.

Photograph by Adrian Davies

1

2

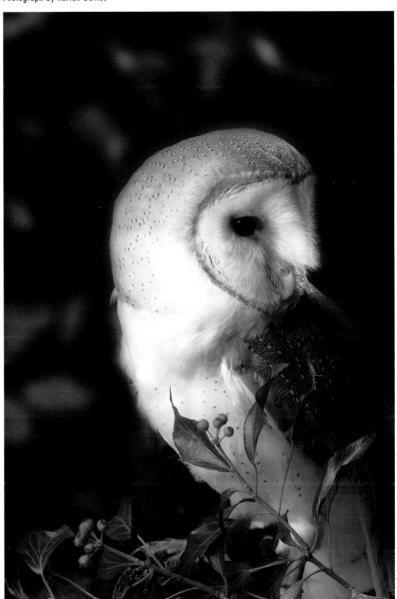

Creating Borders

The finishing touch to a well-produced black and white print is a complementary border and there are many ways to add one of these in the darkroom.

Technique

Depending on how it's going to be presented, a black and white print can look highly effective with a conventional white border and perhaps a surrounding mount to set the image off. There are ways, however, to add a border at the printing stage and this is another option to consider.

The simplest approach is to use the clear film that usually surrounds the image on a negative and to produce a black border which may also include some of the lettering and the corner of a sprocket hole or two for effect. This is easily done by filing away at the edges of a negative carrier so that more of the negative than usual is visible, and the rougher the effect you achieve, usually the better it looks.

A way of creating a neater look is simply to use a negative carrier that is larger all round than the negative itself – for a 35mm negative, for example, you could use a 6x6cm carrier – and then the width of the black line that will be formed around the print can be measured precisely through an adjustment of the masking frame.

Variations

If the negative is to be cropped the technique becomes slightly more complicated. Here you will need to place a mask over the paper to protect the part where the image will fall while the black line is being exposed. Compose your image on the easel and then move the easel blades out by a few millimetres to create the space for your key line. Next you need to trim a piece of opaque material to the size of the image (excluding the key line area) and then this is put to one side and the print is exposed in the usual fashion. Once this is done the opaque material is placed carefully in the centre of the paper and held in place with small weights, such as coins. Remove the negative from your enlarger's carrier and then shine white light onto the paper for a few moments, which will be enough to turn the narrow strip of paper around the print a deep shade of black.

Technical Tip

Producing prints that feature the edges of the negative is an effective way not only of displaying your work, but also presenting the viewer with the full image, a point that makes this approach particularly popular with the art market.

Right: This picture of Lawrence Huff's was produced as a limited edition platinum print. For prints of this kind the paper is sensitised by hand and the emulsion is applied with a brush. Extending these brush marks beyond the borders of the print allows a very pleasing and individual rough finish.

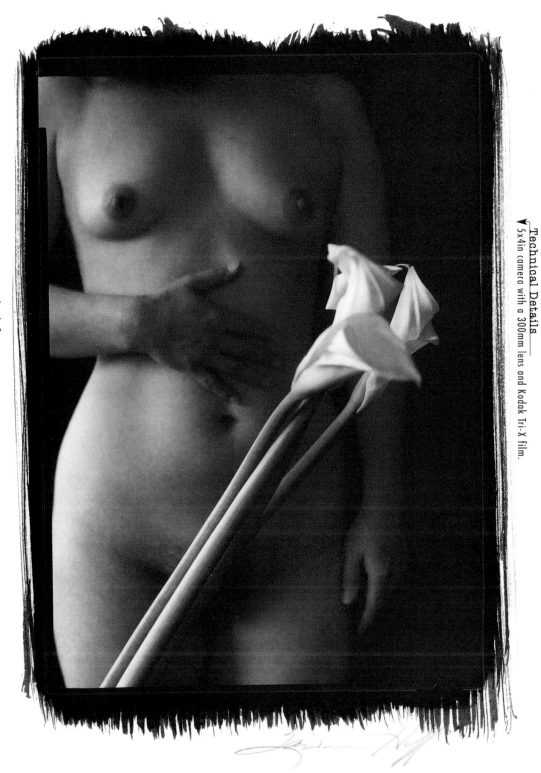

Photograph by Lawrence Huff

Technical Details
▼ 5x4in camera with a 300mm lens and Kodak Tri-X film.

Exhibiting Your Prints

So many photographers take enormous care over every aspect of their photography only to neglect the final step, the presentation of images. Fall at this last hurdle, however, and you could ruin the whole effect of your pictures.

Pros & Cons

You should ask yourself why you're spending time and enormous effort over your black and white photography. If it's purely for your own satisfaction then that's fine, but it can be enormously satisfying to see your work exhibited or even hung in the homes of friends and family.

To reach this stage, however, you'll need to take care over the presentation of your work. Prints will need to be washed thoroughly following completion so that they are completely free of chemicals and will be archivally secure. You may even want to consider applying a tone, such as selenium, that will increase the longevity of the image while also adding a subtle bluish feel to the picture. Make sure you spot every print that you want to show carefully with archival inks so that it has a clean appearance and follow a strict quality control regime so that any pictures which are not up to standard – perhaps featuring an area where the grain has moved out of focus – are not distributed.

Visit an art shop and ask for advice on mounts and their preparation. Photographs intended for long-term display will need to be paired with acid-free mounts so that they are not damaged over a period of time by the natural ingredients found in conventional card. There are also specialist tools which you can obtain that allow bevelled corners to be cut with complete accuracy. It may seem like a small point but many prints will have their impact taken away by scruffy, poorly finished mounts and you should make sure that this is one detail you don't overlook.

As shown by these examples, the size and colour of the frame and mount have a subtle impact on the way the image appears. Try out a variety of different frames and mounts to see which suits your image best.

Glossary

Aperture Priority
An auto-exposure setting in which the user selects the aperture and the camera's exposure system sets the appropriate shutter speed.

Auto Bracketing
A facility available on many cameras, which allows three or more exposures to be taken automatically in quick succession giving both more and less than the calculated exposure. Usually adjustable in increments of one third, half or one stop settings and especially useful when shooting colour transparency film.

Bellows Unit
An adjustable device that allows the lens to be extended from the camera body to focus at very close distances.

Bounced Flash
The technique of reflecting the light from a flash gun from a white ceiling or wall in order to diffuse and soften the light.

Bromide Paper
A printing paper that gives a blue-black image when the appropriate developer is used.

Burning
The giving of additional exposure to selected areas of a print that would otherwise register as too light. (See Dodging).

Cable Release
A flexible device which attaches to the camera's shutter release mechanism and which allows the shutter to be fired without touching the camera.

Camera Movements
Vertical and swing movements that can be made with the lens and film plane on a studio camera to perform various functions, such as increased depth of field and correction of converging verticals.

Compressed Perspective
Distant perspective that's been brought up close by the use of a telephoto lens.

Depth of Field
The distance in front and behind the point at which a lens is focused which will be rendered acceptably sharp. It increases when the aperture is made smaller and extends about two thirds behind the point of focus and one third in front. The depth of field becomes smaller when the lens is focused at close distances. A scale indicating depth of field of each aperture is marked on most lens mounts and it can also be judged visually on SLR cameras which have a depth of field preview button.

Dodging
The holding back of certain areas of the negative during printing to reduce print density, allied to the selective increase of exposure to certain areas of the print that require increased density. (See Burning).

Downrating
The opposite to uprating and primarily done to reduce contrast. The film is shot at a lower ISO rating and, to compensate for what is effectively overexposure, the film is developed for a shorter time.

Dual Toning
The technique of placing a print in two separate toning baths to pick up elements of both colours.

Extension Tubes
Tubes of varying lengths which can be fitted between the camera body and lens used to allow the camera to focus at close distances. Usually available in sets of three varying widths.

Farmer's Reducer
A mixture of potassium ferricyanide and sodium thiosulphate that will lighten selected areas of a print.

Field Camera
A large format camera that has been specially designed to be used on location.

Fill In Flash
A camera setting, for use with dedicated flash guns, which controls the light output from a flash unit to be balanced with the subject's ambient lighting when this is too contrasty or there are deep shadows.

Filter Factor
An indication of the amount the exposure needs to be increased to allow for the use of a filter, a x2 filter needs one stop extra exposure, x3 one-and a-half stops more and x4 two stops more, and so on.

Fogging
The effect of exposing film or paper to unsafe ambient light, often caused by a light leak in a darkroom or a safelight which is too bright or has the wrong screen. A good test for this is to place an opaque object, like a coin, on a piece of photographic paper and leave if for twenty minutes or so in the darkroom before processing it.

Grain
The structure of a film's emulsion which can become visible at high degrees of enlargement. It is more prominent with fast films and can be used for creative effect.

Grey Scale
A card of average tone which can be placed in a scene that's difficult to meter to ensure an average reading can be taken.

Incident Light Reading
The measurement of light falling onto a subject rather than that reflecting from it. This is useful when faced with a scene that's full of light or dark subjects that might confuse the meter.

Infrared Film
A film that responds to the different reflecting powers and transparencies of objects in the picture to infrared and visible radiation, producing a series of bizarre tones.

ISO Rating
The standard by which film speeds are measured. Most films fall within the range of ISO 25 to ISO 1600. A film with double the ISO rating needs one stop less exposure and a film with half the ISO rating needs one stop more. The rating is subdivided into one third of a stop settings i.e. 50, 64, 80, 100.

Lith Printing Paper
A printing paper that increases the contrast levels in a scene while allowing shadow detail to be retained. Its characteristic feature is a pink tone.

Macro Lens
A lens which is designed to focus at close distances to give a life-size image of a subject.

Mirror Lock
A device which allows the mirror of an SLR to be flipped up before the exposure is made to reduce vibration and avoid loss of sharpness when shooting close ups or using a long-focus lens.

Neutral Density Filter
Used to cut down the light reaching a film by a stated amount and absorbs all wavelengths almost equally, ensuring no influence on the tones each colour will record as on black and white film.

Polaroid Type 55 Film
One of the oldest Polaroid film materials available, which gives the photographer both a print and a negative.

Programmed Exposure
An auto-exposure setting in which the camera's metering system sets both aperture and shutter speeds according to the subject matter and lighting conditions. Usually offering choices like landscape, close up, portrait, action etc.

Rangefinder Camera
A camera that features two separate images in the viewfinder that come together as the lens is focused.

Reciprocity Failure
The effect when very long exposures are given. Some films become effectively slower when exposures of more than one second are given and doubling the length of the exposure does not have as much effect as opening up the aperture by one stop.

Selenium Toning
A brief immersion in selenium toner at about one part concentrate to 15 parts water should not change print image colour but it will improve the archival permanence of the print. The toner must be used in well-ventilated conditions.

Split Grade Printing
The technique of using different levels of contrast for specific areas of an image when making prints on a varicontrast paper.

Spot Metering
A means of measuring the exposure from a small and precise area of the image – it is often an option with SLR cameras. It is effective when calculating the exposure from high-contrast subjects or those with an abnormal tonal range.

Stop Bath
An acidic solution which halts the action of the developer when processing black and white film and papers.

Thiocarbamide Toning
A two bath process that can, according to the relative strengths of the components in the toning stage, give a variety of tones ranging from dark brown to yellow brown.

Uprating
Rating a film at a speed higher than its nominal rating and then compensating for the underexposure that takes place by increasing film development.

Varicontrast Paper
A printing paper with which contrast can be altered by the use of coloured filters, also known as Multigrade.

White Reflector
A board or sheet that is positioned to bounce light into areas of shadow.

Biographies

Naseeb Baroody, MD, is a cardiologist whose interest in photography was triggered in the 1940s after reading 'Life' magazine, particularly the issues related to World War II. He soon began to experiment with processing and now has a fully equipped darkroom. He finds his inspiration from 'lighting', 'subject matter' and 'record shots'.
Address: 915 Mohawk Drive, Florence, SC 29501, USA.
Tel: +1 843 669 6486/1 843 777 2808
Fax: +1 843 777 2829
Email: nbbmd@aol.com
www.baroodyphoto.com

John Benigno became interested in photography at the age of 10. He was being kept in isolation after a bout of whooping cough when his father brought him a camera as a get-well present. In high school he was the photographer for the yearbook and newspaper, and only during the last decade has he pursued it as a serious hobby concentrating on fine art photography, primarily landscape and occasionally still life. His work has been collected by a number of museums.
Address: Photographic Images, 597 Hansell Road, Wynnewood, PA 19096, USA.
Tel: +1 610 642 5659
Email: japenigno@earthlink.net
www.home.earthlink.net/~japenigno

Darin Boville began his career as a photographer in the early 1980s whilst living in Akron, Ohio, and completed a number of exhibitions and a solo exhibition in 1987 before taking up a degree course in Public Policy, due to lack of funds. He fully expected to devote himself full-time to this new career until graduation when he once again began to 'see' photographs. Since this time he has built up a new body of work and has put on his first on-line show.
Email: darinb@aol.com / darin@darinboville.com
www.darinboville.com

Bernard Carrette has been practicing black and white photography for the past 20 years. He has not had any formal training and honed his skills through reading and studying the work of professional photographers and then putting this knowledge into practice.
Address: Avenue des Mesanges 98, B-1480 Clabecq, Belgium.
Tel: +32 2 355 69 05
Email: bernard.carrette@skynet.be
http://users.skynet.be/darkandlight

Dominic Ciancibelli attended the Dayton Art Institute and graduated with a major in Sculpture in 1967. This was followed by work as a tutor in sculpting and a series of shows. In 1972 he undertook a one-person photographic show and since this time he has concentrated on photography whilst developing skills in the digital domain.
Tel/Fax: +1 360 673 4605
Email: dominic@scattercreek.co / dominic@kalama.com
www.themindseye.net

Craig Wallace Dale attended the Brooks Institute of Photography and moved to New York comparatively recently in his career assisting, amongst others, Irving Penn for three years. He has now launched his own career as a photographer concentrating on editorial portraits and corporate brochures. Landscape work is followed as a hobby.
Address: 800 Park Avenue, 5R Hoboken, NJ 07030, USA.
Tel: +1 201 795 2125
Email: cwd@craigdale.com
www.craigdale.com

Adrian Davies is a natural history and wildlife photographer, as well as a lecturer in digital imaging techniques. He has published six books on various photographic and natural history topics and over 50 articles in various magazines. He lectures regularly at various seminars, including the annual Focus on Imaging Show at the NEC in Birmingham.
Address: 121 Newton Wood Road, Ashstead, Surrey KT21 1NW, UK.
Tel: +44 (0)1372 81 56 53
Email: adavies@nescot.ac.uk

Lorenzo DeStefano was born in Honolulu, Hawaii, and began working in high school as a location photographer for local and national film and television companies. Before moving to California in 1973 he photographed extensively in Europe and then turned his attentions from still photography to writing, directing and editing for film and television. His interest in photography was reawakened during his first visit to Cuba in the summer of 1993 to stage bilingual theatre. He has now published a book, 'La Hora Magica/The Magic Hour – Portraits of a Vanishing Cuba', of images captured whilst on a seven-day jeep journey across the country and these photographs are also the basis of a travelling exhibition.
Address: 6163 Glen Alden Terrace, Los Angeles, CA 90068, USA.
Tel: +1 323 466 8376
Email: lorenzo@lorenzodestefano.com
www.lorenzodestefano.com

Glyn Edmunds turned to photography for a living after successfully applying for early retirement at the tender age of 49. He specialises in portraiture and was recently promoted to the Photographic Alliance of Great Britain list of judges. He has lectured throughout the UK and is to travel to South Africa to speak to the Photographic Society of South Africa's Annual Conference.
Address: 42 Beach Road, Hayling Island, Hampshire PO11 0JG, UK.
Tel: +44 (0)2392 36 65 53
Email: glyn.edmunds@which.net
www.glynedmunds.com

Lloyd Erlick graduated with a degree in psychology but chose instead to follow a career as a black and white portraitist. His aim is to collaborate with his subjects to produce an accurate portrait. He entered the MILK international photographic contest and was awarded first place with his portrait of Great Grand Nana.
Address: Toronto, Canada.
Email: lloyd@the-wire.com
www.heylloyd.com

Greg Fight took a degree in Fine Art Photography at the Florida State University as a second career after leaving the military. In 1977 he joined a small weekly newspaper and ten years later joined the photographic staff of the 'Tampa Tribune' in Lakeland, Florida. Through work he is involved with digital technology but his first love in photography is black and white printmaking.
Email: fight@gate.net fight@gate.net

Andy Finney trained as an engineer and spent many years working for the BBC in radio and television production, and worked as producer on the BBC Domesday Project, a gigantic audio-visual database on videodisc, documenting British life in the 1980s. From here he spent time producing interactive compact discs and web sites. He is co-author of the standard text on the management of new media projects, 'Managing Multi-media', and consults on, and monitors, progress of new media projects for the British Government and European Commission. More recently he became interested in infrared photography, concentrating on monochrome, and showcases his work through the Invisible Light web site. He has configured a digital camcorder to shoot movies in infrared.
Tel: +44 (0)1483 42 79 82
Email: andy@atsf.co.uk
www.atsf.co.uk/ilight
www.invisiblelight.co.uk

Chip Forelli specialises in 'enigmatic' black and white landscape prints. He originally trained as an architect but was drawn to photography, which he found to be a complementary science. He now works on photographic campaigns for prestigious advertising and corporate clients as well as periodicals. Clients have included BMW, Land Rover, Olympus, Luthansa and American Express. He also finds time to run lectures at the International Center of Photography in New York and has staged a series of one-person shows.
Address: 592 West 42nd Street, New York, NY 10036, USA.
Tel: +1 212 564 1835 Fax: +1 212 564 2109
Email: photo@chipforelli.com
www.chipforelli.com

Alex Gibbons is a student who dedicates as much time as possible to photography. He enjoys working in black and white and concentrates mainly in the areas of landscape and macro, or close-up photography. His interest in photography was sparked at school and he became inspired by the works of Ansel Adams and Edward Weston. Currently, Alex maintains a web site of his work for exhibition.
Address: 143 Park Avenue, Swarthmore, PA 19081, USA.
Tel: +1 610 328 5810
Email: galex@home.com
www.members.home.net/galex

Robert Howells has been interested in photography since 1982 and describes himself as a self-taught serious amateur. He has had his work published by local book publishers and in brochures by the local authority. In the late 1990s he obtained a distinction in a City and Guilds photography course and enrolled on a BA in photographic studies. Since this time he has started an imaging company working with all sorts of film and digital based media.
Address: Y Bwthyn, Llwyncoed Road, Blaenannerch, Aberporth, Cardiganshire SA43 2AN, UK.
Tel: +44 (0)1239 81 15 04
Email: robert@coast-tv.demon.co.uk
www.coast-tv.demon.co.uk

Lawrence Huff graduated as a Bachelor of Science from the University of Georgia. Since then he studied at a number of workshops to aid him in his photographic career. He works exclusively with large format cameras and his work is presented as limited edition, hand-coated platinum-palladium prints. He has been widely exhibited and published.
Address: 1326-1 Miyayama, Kamogawa, Chiba 296-0112, Japan.
Tel: +81 0470 97 1440
Fax: +81 0470 93 5254
Email: platinum@olive.ocn.ne.jp
www.platinum-prints.com

Libor Jupa was born in 1948 in Prague and attended the School of Figural Photography and the School of Czech Photographers Association in Brno. In 1982 he left Prague as a political refugee and settled in Ontario, Canada. Since leaving Prague he has been able to work as a professional photographer, strictly in black and white, and concentrates on landscape and still life. He also teaches black and white photography and darkroom techniques and exhibits his work.
Address: 23 Prince Edward Drive, St. Catharines, Ontario L2N 36G, Canada.
Tel: +1 905 646 0437
Email: ljupa@home.com
www.vaxxine.com.ljupa

Andy Katzung became interested in photography at an early age via a darkroom facility at school. At the age of 15 he was sufficiently inspired to invest in his first 35mm camera and then proceeded to study photography at the Minneapolis College of Art and Design, interspersed with a spell at the photography department of a local arts organisation called Film in the Cities. He now works on locally produced film and video projects, has made a short film, shoots and edits television commercials, and shoots production stills for film projects.
Address: 1922 Sharon Avenue SE No. 2, Minneapolis, MN 55414, USA.
Tel: +1 612 623 3572
Email: katzung@transientimage.com
www.transientimage.com

Zbigniew Kosc studied social psychology in Gdansk, Poland, and conducted research at the Universities of Warsaw and Amsterdam. He later studied photography at the Gerrit Rietweld Academy in Amsterdam, and now works as a freelance photographer and writer. His work can be found hanging in private homes as well as public galleries.
Address: Pieter Langendijkstraat 57-1, 1054 XZ Amsterdam, the Netherlands.
Tel/Fax: +31 20 612 6975
Email: z.kosc@chello.nl
http://members.ams.chello.nl/zkosc
http://puck.wolmail.nl/~kosc

Kerik Kouklis is primarily a self-taught photographer who specialises in platinum prints and more recently gelatin chloride printing-out-paper. He often photographs in fog or very low light, giving many of his images the ethereal and peaceful quality that is becoming his trademark. His work has been exhibited widely and his prints are in a number of permanent collections and many private and corporate collections in the USA, Canada and Europe. His work is represented by a number of galleries and art dealers and has been published in books, calendars, posters, postcards and periodicals.
Address: 900 Mariposite Lane, Placerville, CA 95667, USA.
Tel/Fax: +1 530 621 4846
Email: kerik717@aol.com kerik@kerik.com
www.kerik.com

Ed Krebs was attracted to photography looking through issues of 'Life', 'Look' and 'National Geographic' in the '60s, although he didn't pursue this interest until 1989 when a friend gave him some darkroom equipment. He was instinctively drawn to black and white photography and began to concentrate on his main subjects of interest, children and animals.
Address: Laguna Beach, CA 92651, USA.
Tel: +1 949 499 3061
Email: ekphoto@yahoo.com
www.edkrebs.com

David Myers is an education researcher who devotes much of his free time to photography, particularly the black and white medium. He has sold many of his images and has been commissioned to take a number of portraits. Besides his interest in landscape, still life and portrait work, he is pursuing two special projects: one focuses on images of schools and schoolchildren in the USA and the second looks at families and children in black townships in South Africa.
Address: 4211 Matthews Lane, Kensington, MD 20895, USA.
Tel: +1 301 897 5012
Email: davidm@davidmyersimages.com
www.davidmyersimages.com

Cristina Piza was born in Costa Rica, took her university degree in Mexico City where she worked as a scriptwriter and producer in radio and television, and moved to England in 1987 to study photography. In 1990 she was employed by the Istituto Superiore di Fotografia in Rome and later founded a photographic workshop with a collective of freelance photographers in Berlin. It was during this period that she visited and became captivated by Cuba. There followed an exhibition in London and after a second trip a multi-media exhibition featuring her pictures and the words of the poet John Agard. A further visit was designed to capture a visual impression of the traditions and characters associated with the music of the country and these pictures now adorn a number of record sleeves.
Address: Schildhornstrasse 11, D-12163 Berlin, Germany.
Tel: +49 30 791 1603
Email: cristipiza@aol.com
www.freelens.com/piza
www.argus-fotokunst.de

Gerard Rhinn lectures in mathematics although photography is his passion. He has exhibited in the east of France but prefers to self-publish his images on-line. Many of his photographic images are shot during random walks.
Address: 4 Rue Copernic, F57300 Hagondange, France.
Tel: +33 3 87 71 74 36
Email: grhinn@i2m.fr / rhinng@aol.com
www.rhinn.com

Ron Rosenstock was moved to study photography after a visit to the Museum of Modern Art in New York. He graduated with an MA degree in photography, has had his work published in two books and selected by a number of permanent art collections, plus numerous private collections. He now conducts scheduled photographic tours to Ireland, Italy, New Zealand, Morocco and Peru. He has also worked extensively in Ecuador, the Galapagos Islands, Nepal, India and Kenya.
Address: 91 Sunnyside Avenue, Holden, MA 01520, USA.
Tel: +1 508 829 6052
Fax: +1 508 829 6802
Email: ronvoy@aol.com
www.ronrosenstock.com

Debi Scott moved to Arizona in 1960 with her mother and sister and her passion for the desert was born. She currently juggles the occupations of an information technology system engineer with that of a fine art photographer. Her images, which are often hand-coloured or manipulated, are the landscape according to her imagination. She has had her photographs published in books and periodicals, has undertaken a number of exhibitions and been the recipient of many awards.
Address: 4616 West Dobbins Road, Laveen, AZ 85339-9739, USA.
Tel: +1 602 237 3930
Email: debimages@aol.com
www.members.aol.com/debimages

Youry Vinetsky was born in Moscow in 1970 and worked as a designer for many years before creating his own studio. Since then he became increasingly interested in photography and now works as a professional photographer. He concentrates on still life, portraits, nature and architectural work.
Tel: +7 095 127 57 44
Email: art@ilm.net
www.vinetsky.com

Pie de Vrede has been interested in photography since 1970. He describes himself as a photographic opportunist, which is mainly attributable to his busy career as an information/automation manager and advisor. He lives in the Netherlands, but finds a lot of his photographic inspiration when he travels abroad on holiday.
Address: Wethouder Vrankenstraat 18, 6227-CK Maastricht, the Netherlands.
Tel: +31 43 361 3955
Email: pie.de.vrede@wxs.nl
http://home.wxs.nl/~vrede021

Wynn White was born in the northwestern United States but has spent 25 of the last 30 years in Japan where he has his darkroom and studio. He first became involved in photography on a naval trip to Japan in 1970, and although he later studied Pre-hispanic Art and Economics, his interest in photography prevailed. He is self-taught through trial and error and by studying photographic works in galleries and museums. He has had his work exhibited in Japan and the USA and been published in Japanese magazines. He has appeared on NHK television as a lecturer on black and white photography.
Address: 313-61 Warabi, Yotsukaido, Chiba 284-0044, Japan.
Tel/Fax: +81 0434 20 4315
Email: wwphoto@w.email.ne.jp
www.ne.jp/asahi/ww/photo

3001479

Property of the College of West Anglia
If found, please return to
The Learning Resource Centre